the blue book

the blue book

a writer's journal

amitava kumar

HarperCollins *Publishers* India

First published in India by HarperCollins *Publishers* 2022
4th Floor, Tower A, Building No. 10, Phase II, DLF Cyber City,
Gurugram, Haryana – 122002
www.harpercollins.co.in

2 4 6 8 10 9 7 5 3 1

Copyright © Amitava Kumar 2022

P-ISBN: 978-93-5489-374-2
E-ISBN: 978-93-5489-382-7

Cover and inside design: Gavin Morris
Author photo: Imrul Islam

Printed and bound at
Lustra Print Process Pvt. Ltd

In the journal I do not express myself more openly
than I could to any person; I create myself.
The journal is a vehicle for my sense of selfhood.

Susan Sontag

I've always loved painting, although I never show anyone
what I've done. Mainly because I don't do it well.
But it's like a form of visual diary for me.
A way of fixing things in my mind.

Judi Dench

Painting is just another way of keeping a diary.

Pablo Picasso

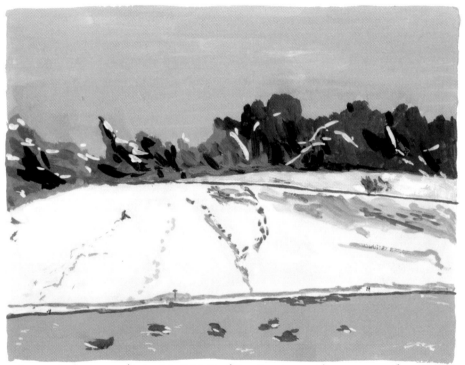

Sunset Lane Dec 17, 2020, After the snowstorm

This book is dedicated to my father who, as is only proper, loves his grandchildren more than he loves me.

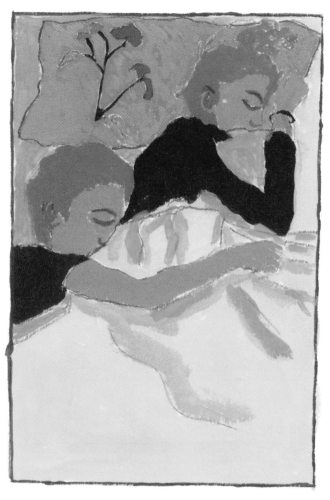

My sleeping kids, May 2020

In an essay titled 'The Writer as Father', which I wrote
ten years ago, I noted that there is a word in the English
language for loving one's wife too much, but none
for lavishing too much affection on one's daughter.

Contents

Introduction

— and in 'Portnoy's Complaint' I think I was able to do that, to unshackle myself from certain rules of literary conduct."

Twenty-five years later, in the chaste pages

both a per
Roth chuck
title is still
added tha
turbing el
function. '
claimed to
were offen
"But that's
bation. Wh
the depicti
family."

For M
general, "
an era — t
old literar
rules of lit
was the b
figuring o
any rules
plaint' I th
of hyperr
would it y
very much
What coul
way it was
kind of w
have?"

bout
t tell
wen-
sch-
, the
f the
pos-
y of
o be
body
ady a
other
ently
nula-
ns to

"**M**RS. DALLOWAY said she would buy the flowers herself."

*ing

Manoj

THE STORY OF AN INDIAN FILM-STAR ACTOR

TLS, June 21, 2002

From Granta, *May 2018*

What you see on the left are images from my notebooks that I posted on my Instagram. Clippings, quotes, sketches. These notebooks represent the many years I had lived with the idea of a book that turned into my 2018 novel, *Immigrant, Montana*. (It was published in India under the title *The Lovers*.) When I went to a writing residency one summer, it was the notebooks that I looked through each morning and night—these notebooks are a visual reminder of all the bits and pieces I was thinking about when writing that novel.

The picture on the top left is of Philip Roth. There's a story there. I wanted to call my novel *The History of Pleasure*. The second picture on the right is an image, perhaps from a telefilm, I can't remember, made from a Joyce Carol Oates story titled 'Where Are You Going, Where Have You Been?' I wanted sex as my subject, not only the innocence but also the bruising.

Take the sketch right below Roth's picture. It is an image from the storyboard for Satyajit Ray's brilliant film, *Pather Panchali* (*The Song of the Road*). The image appears towards the end in my novel. I was thinking about how ordinary life is transformed into art. I put the picture in the book because I didn't want the reader to forget that literature arises from artifice. *Immigrant, Montana* is a novel, then, that is also about writing. But those were the diary entries for *Immigrant, Montana*. The images that are in this book that you hold in your hands are part of a newer, more

recent history. A history that still surrounds us. What I'm sharing here in *The Blue Book* are my drawings and writings that have occupied me while writing a new novel, *A Time Outside This Time*. For the past two years, I have been painting watercolours. Like my novel, these drawings are a response to our present world—a world that bestows upon us love and loss, travel through diverse landscapes, deaths from a pandemic, fake news and, if we care to notice, visions of blazing beauty.

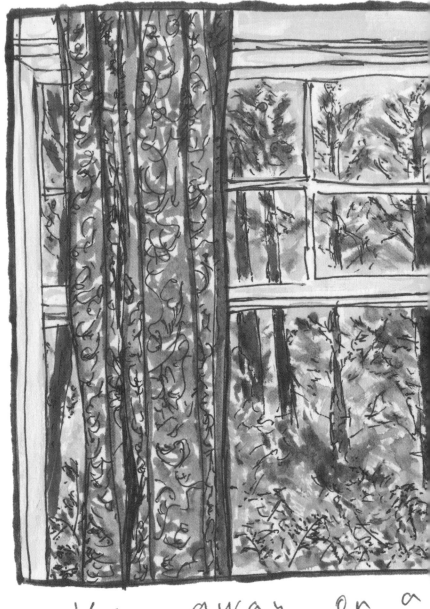

I'm away on a

Writing about th

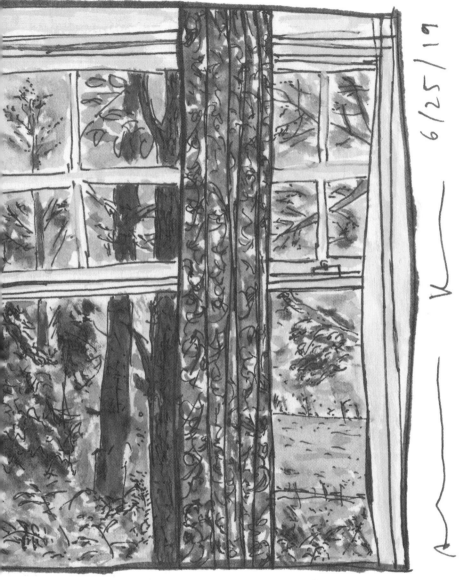

6/25/19

MacDowell residency
rotten presidency

Residencies

Pinto Canyon Road
I turned to look right

Early morning.
when Douglas rode past.

I arrived in Marfa in January for a writing residency;
I was inhabiting this dream of creation. I was
completing a novel but each day I also drew or
painted. A quick sketch or watercolour, put down
without fuss, a record of what I was seeing.

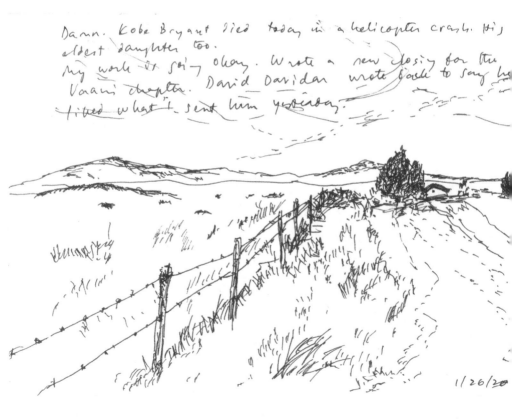

Damn. Kobe Bryant died today in a helicopter crash. His
oldest daughter too.
My work is going okay. Wrote a new closing for the
Vaani chapter. David Davidar wrote back to say he
liked what I sent him yesterday.

1/26/20

The lady who supplied eggs to the feed store found
love online and sold all her hens and moved to
Virginia. Only store-bought eggs here now. Anyway,
today I started reading
the Berger bio by
Joshua Sperling.

1/23/20

Marfa, Texas, 2020

Marfa, Texas, 2020

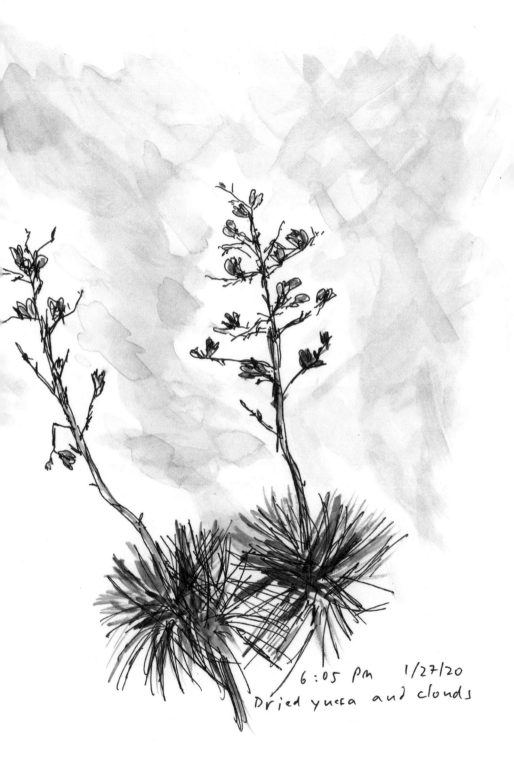

6:05 pm 1/27/20
Dried yucca and clouds

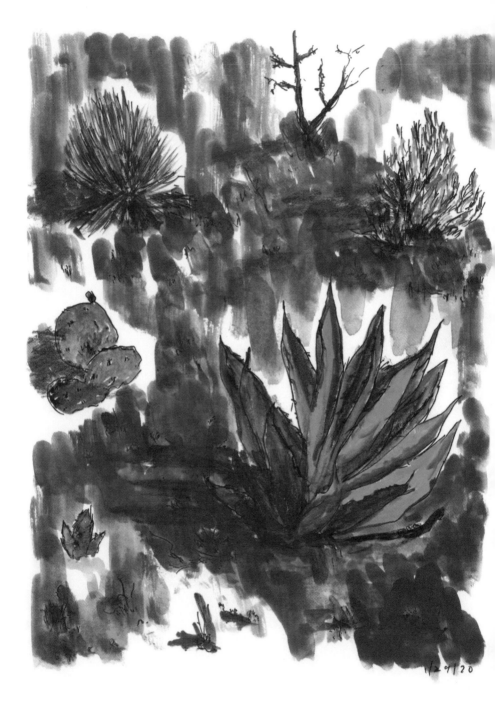

1/29/20

David Foster Wallace was a resident twenty years before me in that house in Marfa. In his report at the end of his residency, he wrote this about the place: 'The whole trans-Pecos is haunted. Some of this is the high desert, where nothing has a shadow and storm clouds seem just out of reach. Some of it is quiet, which is so profound it becomes its own hum. It is country that wants nothing from you, where it is impossible to take yourself seriously. A fruitful state to be in, work-wise, usually.'

The story I was writing in Marfa was set in a place very different from the desertlands of south-western Texas; in the pages I wrote every day, the mood was different and so were the colours. But whenever I painted in Marfa I was always haunted by the images and sounds made by Foster Wallace's words.

Marfa, Texas, 2020

It is always about the sentences. I like the sentences written by my friend Ian Jack, a regular contributor to *The Guardian*, *Granta* and the *London Review of Books*. I especially like his reports from the subcontinent because in India even reporters can often sound like bureaucrats. Here is his description of the slain prime minister Rajiv Gandhi's funeral in 1991: 'His garlanded body moved on a gun carriage through a great crowd; by the river Yamuna it was raised to a pyre of sandalwood and was there consumed by flames; smoke rose into the evening sky over Delhi.' This is very good, the shape of the sentence mimicking a process, and a ritual, that took place over time—and how wonderful that the sentence ends not with a fall but with a rise. It is as if Gandhi's soul had found release. There is a lot of grace in that sentence.

Sharp writing, edged with irony and humour, with a particular interest in historical oddities—it is a surprise to find these qualities in Jack's reports from places that usually enter Indian newspapers only in the form of dull, perfunctory copy filed by stringers.

Here he is again, in 1983, reporting from Motihari in my native Bihar, recording for us an old lawyer's memories of opium farming in Champaran: 'The smell of those poppies is still in my nostrils and the rattle of the poppy seeds is still in my ears.' He said it was a lovely sound, 'softer, more sonorous than a baby's rattle', which came from the poppy fields in the lightest breeze. I rely on Ian to tell me the truth not only about the

world on which he reports but also my own work. He had worked as an editor, most notably at *Granta*, for long stretches of his life, and he is never mealy-mouthed when offering judgement. I often think that Ian's special skill is in appearing, even deceptively, plain and direct when the truth is that his writing is full of wit and style. I'm thinking of Ian while putting together this book in particular because he hasn't been a man in favour of my turn towards the visual.

When I was in Marfa for my residency, working on the new novel, I wrote to Ian. I told him that I was planning to include some drawings in the book. My thinking was that if this idea passed muster with him, I was safe. But I wasn't. I wasn't safe at all: Ian was against the idea. Below is the note he wrote to me in response:

> I was just thinking today of my many weaknesses as an editor, which include a prejudice against any piece that mentions Walter Benjamin and (more seriously, and not something to take pride in) a distaste for anything that calls attention to the author's imagination. 'Danger: Imagination at Work' would be one of my favourite road signs, if novels were roads. Imaginations should be the opposite of Victorian children: heard but not seen. Etc. So obviously I'm not going to like your idea of including your drawings in your text, even though some children's writers do both, and very well too. I should also warn you that colour reproduction costs a bomb, and that, while I've seen novels that include monochrome photos (Sebald started the trend) I've never seen one

Chisos Mountains, Texas, 2020

02/08/20

that had its text illustrated in full colour. What it would suggest (to me) is a narrator who's a little deranged and has taken up painting as a therapy. Of course, there's a first time for everything. Not for me, who would certainly have rejected *Finnegan's Wake*. But maybe for you?

I readily gave up the idea and then, after months passed, I felt I should keep at least one drawing in the book. I needed it to make an important point. Which is to say, Ian has been an influence. Then, when I published a 'pandemic diary' in *The Indian Express*, I sent the link to Ian. Once again, Ian expressed his disapproval in his own wonderful way:

> I see you have taken up the visual arts, as threatened. I am a poor judge of these things—I would certainly have shown the door to Andy Warhol and his soup cans and the guy who specialises in arrangements of pots and pans. Your pictures announced their message with a trumpet-like clarity by comparison—but I still think writing is the more difficult and the more honest endeavour.

What makes writing difficult? In my copy of his book *Mofussil Junction*, Ian had written: 'The truth is impossible. The big idea is to try to tell it.' Each year, I teach my journalism class Ian's essay 'Unsteady People'. It begins with a description of an accident on the Ganges near Patna and then moves on to the death of ninety-six soccer fans during a crush at Hillsborough

stadium in Sheffield. The essay rescues my students from their provincialism; more important, it asks us to discard our delusions. Another favourite of mine is Ian's essay about the sinking of the *Titanic*, each detail replacing sentimental images with concrete facts. Or a piece about Princess Diana's death. There are several such bracingly sceptical reports that Ian has written and their effect, to my mind, is to demystify, to snatch away, as it were, the veil of illusion.

Even as I wrote the lines above, I thought I should check with Ian. Had I erred, either through inaccuracy or hyperbole? I ought to have shown these lines to him. Actually, reader, I did show the first paragraph of this piece. I urge you to go back and read it once again before reading further because what I quote below is Ian's response to it. I believe he is right, of course.

> To be honest, when I write sentences I just want to make them convey information in the best order and to sound right—i.e. in some way pleasing, but without trying too hard in that direction. I often think in terms of pictures and then try to find words that will convey these pictures to a stranger. I can't say any more than that. When I wrote 'smoke rose into the evening sky over Delhi' I don't think I intended any more than that picture, but a writer's intention and a reader's inference are different things and the subconscious is at work in each. Still, I think I'd cut, if I were you, the sentence 'It is as if Gandhi's soul had found release.'

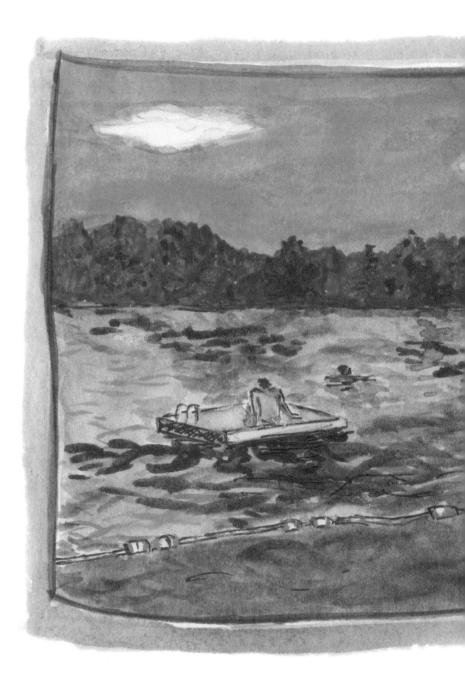

Peterborough, New Hampshire, July 2019

I made the above drawing while I was a fellow at the MacDowell Colony in 2019. Over the last ten years, I have done work that has made it possible to get such opportunities to write. It was impossible to even imagine these breaks twenty years ago, but that is what I did—dream about writing, dream about books. In 1992, my writer–friend Cheryl Strayed, who like me was in her twenties then but younger, had sent me a postcard. It ended with these words: 'My life will not be over until I write one true story. I attempt again today to do it—a single story that illuminates reality and surreality. I am glad that you won't die in a prison cell and I will live forever …' I found the postcard five years ago when I was unpacking my library after moving house. I photographed Cheryl's message and sent it to her. She posted it on social media, saying, 'From the beginning it was ambition, faith, and doubt.'

It was, it was.

The book that Cheryl wrote, *Wild*, became a *New York Times* bestseller and was made into a motion picture starring Reese Witherspoon and Laura Dern.

Joy - a beginning. Anguish, ardor.
To relearn the ah! of knowing in unthinking
joy: the beloved stranger lives.
Sweep up anguish as with a wing-tip,
brushing the ashes back to the fire's core.
-excerpted "A" from Denise Levertov's "Relearning
the Alphabet."

June 11, 1992

Dear

Some poetry in exchange for
Cherries. Send me
your
stories
and
your

love,
Cheryl

Printed in Italy

Amitava Kumar
2357 Carter Av.
St. Paul, MN.
55108

P.S. My life will not be over until I write
one TRUE story. I attempt again today
to do it - a single story that illuminates
reality and surreality. I am glad that you
won't die in a prison cell and I
will live forever................

A young woman got in touch with me to say she was turning twenty-five. I didn't know her but she had gone to India three years earlier to work in a women's prison near Mumbai. She was asking twenty-six artists or writers whose work had been meaningful to her to contribute a journal entry for a day in July. We were to reflect on what it had been like at twenty-five. What you see on the right is the note I sent her.

Peterborough, New Hampshire, 2019

WHEN I TURNED 25, I WAS
ADRIFT, ARTISTICALLY AND ALSO
EMOTIONALLY. I WANTED TO BE A
WRITER BUT HAD WRITTEN LITTLE.
I LACKED A SUBJECT. ALL THE
FAILURES OF THOSE YEARS, THE
WANDERING, EVEN THE WAYWARD-
NESS, THE ENDLESS WAITING
PROVIDED THE FODDER FOR
WRITING DURING THE NEXT
25 YEARS.
(ART: FERNS @ MACDOWELL COLONY)

3 JULY 2019 AMITAVA KUMAR

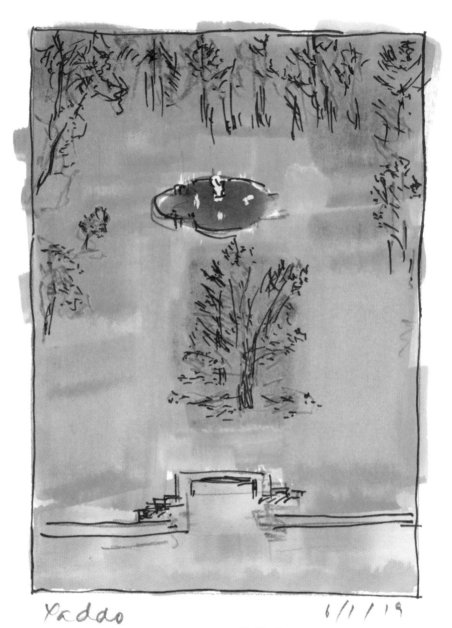

Yaddo

6/1/19

Yaddo, Saratoga Springs, New York, 2019

My thoughts all afternoon have been about John Cheever's journals. Cheever was a regular at Yaddo. The small swimming pool there is his legacy. He often swam naked in it, or so legend has it. But there are also other signs around, a framed letter from him addressed to the director, for example. He was such a supreme stylist, and nowhere is it more evident than in his journals. Here are a few lines from 1963. He has gone to the Shea Stadium for a game. And he embarks on this stylistic riff: 'The sod gleams. This is indeed a park. I think that the task of an American writer is not to describe the misgivings of a woman taken in adultery as she looks out of a window at the rain but to describe four hundred people under the lights reaching for a foul ball. This is ceremony. The umpires in clericals, sifting out the souls of players; the faint thunder as ten thousand people, at the bottom of the eighth, head for the exits. The sense of moral judgments embodied in migratory vastness.'

When I read those lines I asked myself whether I had ever thought the same way, say, about the rituals of cricket? Yes, at odd hours of the night, when it was day elsewhere in the world, I had watched Virender Sehwag bat, his stocky body looking compact, like a small sack full of bombs. Like his other fans, I too loved his aggression and his contempt for milestones. I had read somewhere that Sehwag learned to speak English only after he had become a star going on foreign tours. People always talked of his roots in rural Najafgarh, his ordinariness as the key to his

uncomplicated approach to cricket. With Sehwag in the picture, every cricket commentator became a nerdy sociologist. Reporters too. 'To India's impoverished youth, Sehwag is the man of clay astride the mountain of the gods. His parents still have a buffalo in their yard.'

In the same way that Cheever wrote of liquor and lust and his longing for success, I have sometimes wished to write about the mid-level actors in Bollywood, those inhabiting the fringes of stardom, those with enough talent to want the spotlight but enough knowledge to suspect that it will never be theirs. Over the years, however, riding on the Metro-North from Poughkeepsie to New York City and back, passing the town where Cheever lived and Sing Sing prison where he taught writing workshops, I have succumbed to a different literary fantasy. I would like to write a novella that takes no longer to read than my train ride, just under two hours. This desire was born when I read Denis Johnson's *Train Dreams* on one of those journeys. A small book that is so precise and startling in its telling that it feels utterly epic. (Cheever, incidentally, was considered temperamentally better suited to producing short fiction. I once asked Jonathan Franzen about this and he said, 'Yeah. That is not me.' Franzen is famous for his big novels. Why did he prefer them to something shorter? Franzen told me, 'The sad fact may be that I don't have a story-telling imagination. Unless I'm doing non-fiction, where real life provides the story, I need to get the

heavy machinery of a novel in motion, need to develop a set of characters and a world for them to inhabit, to compel me to invent.')

I no longer want to write of cricket or Bollywood; I'd like to imagine instead the span of an ordinary life spent on the outskirts of a big city in India. After the December 2012 gang-rape of a young Delhi woman on a bus, the father made a remark in an interview that has stayed with me. He told the foreign journalist, 'I heard once that to escape poverty you need to work like a horse and live like a saint.' I liked that. I think my novella will be titled *Live Like a Saint*.

Days of Absence, Saratoga Springs, New York, 2019

When I was at Yaddo one summer, I painted this
for my wife because I was missing our wedding
anniversary. I wanted to tell her that I loved her and
missed her. To be honest, I was afraid that she would
be pissed. A somewhat typical plot line, I realize,
but often our lives run along conventional tracks.

I once asked one of my early heroes, Hanif Kureishi,
whether he wanted to go to a writing residency. No,
he said, I'd miss my kids too much.

On the night before I went to Yaddo the first time,
my son, who must have been five or six at that time,
climbed inside my open suitcase. He fitted quite easily
into it. Take me with you, he said.

Words come at a price.

Journeys

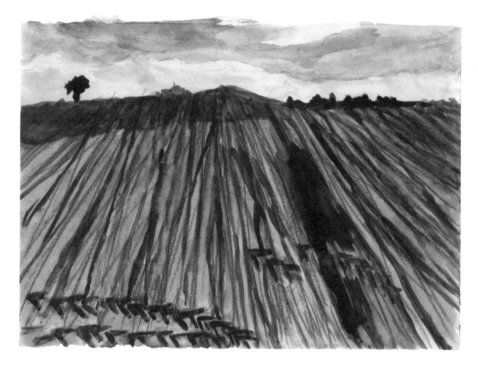

La Côte-Saint-André, France, 2019

I like that travel gives you new eyes. When I arrive in a town, and am taking pictures, I realize that most often my best shots are the ones taken on the first day. Intimacy is overrated; newness is everything.

What do I hate about travel? I feel my age when I travel. My body aches, I want to lie down. I crave silence. The presence of large crowds in packed enclosures, waiting to criss-cross the earth, makes me think of what we are doing to the planet.

When I was a student in Delhi, I would go to ISBT and catch a bus that would take me out to the small towns in the hills. Almora, Bhimtal, Rishikesh. The trip was inexpensive and I relished the feeling of freedom. What matters in the end, however, are the stories that people offer. I value that encounter more than the place.

I don't generally enjoy the journey as much as I do finding leisure at my destination. But even as I say that, I realize that it's not entirely true. Often, especially during a comfortable train ride, I will begin to take notes about writing, sometimes about what I'm already working on, at others about new projects that had so far stood in the shadows. It's a luxury, this gift of isolation.

My most memorable such journey was a trip to London from New York. I was serving on the jury for a literary prize. The ticket was for business class. I sank into the rare extravagance of the moment and began work on a short story. I think it was done by the time we arrived.

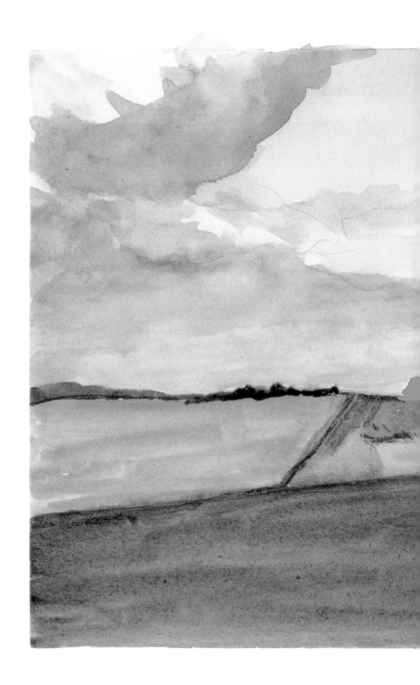

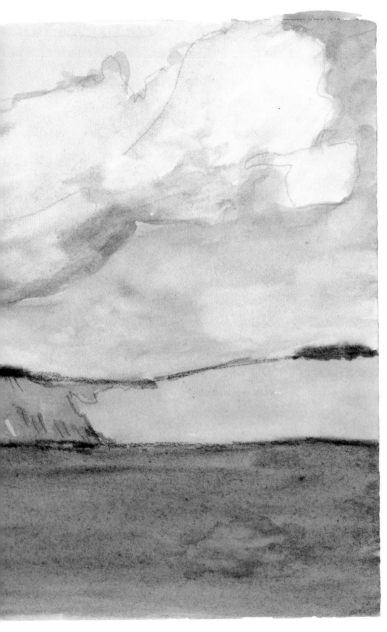

View from the train back from Lyon to Paris, France, 2019

My French publishers, Gallimard, had brought me to read at a litfest in Lyon. On the way back, in Paris, I was near the Sorbonne taking a picture of Montaigne's statue when I heard someone calling my name.

Turning back, I saw the writer Amit Chaudhuri waving at me from across the street. What a fine surprise! Amit wanted to first buy a particular kind of cake that was available at a nearby store and then we went to Shakespeare & Co. where my former colleague Michael Hofmann was reading from his poems.

Amit and I walked around afterwards, stopping first for dinner and then, after more wandering, dessert. The general election results in India had just been announced. The BJP had won by a huge margin. During our aimless walking around the gutted Notre Dame Cathedral, Amit pressed me with questions that I didn't have answers for. Why had the election results surprised so many? What makes it difficult for educated liberals to see the truth about the ascendancy of right-wing forces? Why are we so ineffective in our dissent?

I didn't have any answers for these questions, or at least I didn't have answers that would fit as opinion. Instead, for the past several years, I have wanted to address such questions obliquely or even directly only in fiction. So, I didn't answer Amit and instead suggested that we take selfies to send to his wife.

Earlier in the day, two girls had stopped me on a bridge near the Notre Dame Cathedral. They wanted me to sign a petition requiring the state to provide them with hearing aids. When I read the petition, I suddenly understood why the girls had been making humming noises instead of articulating words. They were deaf and dumb.

After I had signed the petition, they pointed to a column on the paper where I was supposed to indicate how many euros I was donating to the project. The column showed donations of 20 euros, 25 euros, even figures higher than that. I didn't want to pay.

I said, in English, but also with many gestures, I cannot pay that much. I'm sorry, I'm sorry.

My statement brought about a remarkable cure. Both girls suddenly acquired their hearing as well as their ability to talk.

They sang out loudly, 5 euros, 5 euros.

I was headed to the Mildura Writers Festival near Melbourne. My first trip to Australia. I drove from my home in upstate New York to Newark airport. After a three-hour wait, a five-hour flight took me to Vancouver; another wait, shorter this time, and then a sixteen-hour flight to Melbourne. By the time my baggage arrived, I had missed my short flight to Mildura. I didn't care because the only thing that was real was the fatigue that had seeped into my bones and sealed my joints.

I felt I had aged ten years. Or, more likely, twenty. Had my hair been so grey before I left home? I doubted it. My children, whom I had left behind, must have grown older. And my beautiful wife was probably beset by young suitors trying to convince her that I had been gone so long I would never return. I exaggerate, but here's the truth. My legs felt leaden. I wandered around in the airport terminal at Melbourne, remembering those maritime criminals from two centuries ago, their legs bound with rope and weighted with iron before being thrown overboard into the churning waters.

A writer I enjoyed meeting in Mildura was Helen Garner. I had read her brilliant 1972 piece called 'Why Does the Women Have All the Pain, Miss?' Garner was an English teacher in an Australian school. One day her thirteen-year-old students began to giggle and ask questions about the defaced art in their textbooks. The students were curious—and utterly ignorant—

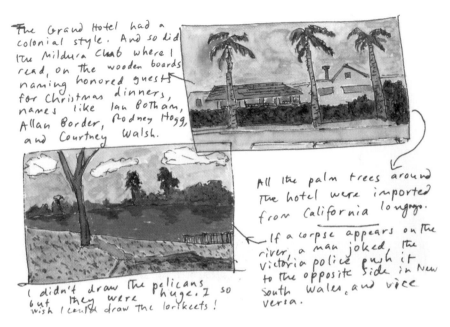

The Grand Hotel had a colonial style. And so did the Mildura Club where I read, on the wooden boards naming honored guests for Christmas dinners, names like Ian Botham, Allan Border, Rodney Hogg, and Courtney Walsh.

All the palm trees around the hotel were imported from California long ago.

If a corpse appears on the river, a man joked, the Victoria police push it to the opposite side in New South Wales, and vice versa.

I didn't draw the pelicans but they were huge. I so wish I could draw the lorikeets!

Mildura, Victoria, Australia, 2019

about sex and Garner decided to answer their questions as truthfully as she could. Her essay described those few days of excitement and discovery; its title was one of the questions a student had asked her. Garner was aware that if the authorities found out that she had used four-letter words in class and discussed sex, she would lose her job. The students knew this too.

But she didn't regret what she had done. She wrote in her account of the experience: 'My head is singing with the astonishing fact that this is the only totally

honest lesson I have ever given, that not a second
of it was wasted, that their attention didn't waver for
a second …'

When the essay was published, Garner was summarily
fired. The teacher's union supported her and called
for a day's general strike. It gave me great pleasure
when I was out walking with Garner one afternoon,
consuming an orange for which the region is famous,
and an audience member walked up to her and told
her with a smile that he had joined the strike back
in 1973 and she owed him a day's wages.

On the long trip back from Australia, I listened
to a book on Audible—*This House of Grief* by Helen
Garner, a classic of non-fiction, a report on the
trial of a man accused of murdering his children. It
offers a model for writing not only about the law but
about life, showing curiosity for the subject at hand.
Curiosity and patience. Also, an open mind shaped
by an intelligence alert to its own prejudices and
predilections. The book made my return-trip bearable
and I recommend it highly; it also offered a different,
deeper pleasure than just meeting the author had
done. So, here's a pro-tip about travel: literary festivals
cannot compete with literature—stay at home and
read a good book.

Denver Botanic Gardens, Colorado, 2019

I have travelled to Colorado for different reasons
over the years. Two years ago, I went to a literature
festival there, although, as you will understand if you
read further, the details are hazy. In Colorado you
can buy substances that are not legal in my own state,
New York. I went to a marijuana dispensary on the
evening of my arrival. The next day, after my session, I
went on a hike. With me was Suketu Mehta who, in
addition to being a great non-fiction writer, has the
uncanny ability to turn into a guide, whether you are
with him in Nagpada in Mumbai, a favela in Rio, a
part of Queens, New York, or, as I was to discover this

time, the wilderness of Colorado. Our companion was Kiran Desai who, apart from being one of the finest writers of fiction, possesses a rare mix of intelligence and sweetness. There is no one like her, and I love her very much. Sabrina Dhawan, who wrote the script for one of my favourite movies, *Monsoon Wedding*, was also to come but, alas, she had to attend her own panel with a name like 'From Script to Screen', or maybe it was 'From Screen to Being Queen'—I don't remember. (Sabrina is a champion *antakshari* player, and I always feel like Porus being brought before Alexander. *Tumhaare saath main kyaa saluk karoon?*)

After we had scaled great heights, or what appeared to me to be great heights, I took out from my pocket what I had purchased at the dispensary. Kiran said no. She adopted the classic posture of a writer: she would be an amused, non-judgemental observer. Suketu, close to Mahatma Gandhi as a Gujarati, chose more dramatically to see no evil, hear no evil, speak no evil. I had to indulge my tastes alone but, you know, writing is a profession that prepares you for solitariness. My companions were patient. I felt good, and then very good.

I didn't want to come down from the mountain. I wanted Uber to pick me up. Alas, no roads. Not even a single bar on the phone to make a call. We wandered down. It was already getting dark. And then we came across an establishment that offered drinks. A car arrived. Back in civilization, I bought a

bottle of bourbon for a folk-musician from Rajasthan who had performed at the festival. I had heard him complaining about not having real liquor to drink. I didn't know his name but I wanted to thank him for his art. He was confused when I gifted him the bottle. We parted.

Near midnight, the phone in my hotel room rang. It was the musician. He had found my name by looking for my photograph in the festival programme. Would I please meet him for a minute?

I put on the lights and, if I remember right, some clothes. One look at the musician and I realized that the bottle of bourbon had been consumed. His hands were folded together and he now opened them. There was a small bottle of *ittar* sitting in his palm. He said he wanted to give me a gift too. I thanked him but felt I needed to show my appreciation. Quickly, I removed the bottle's cap and dabbed my wrist with that perfume from Rajasthan. At times, I feel I can still smell it.

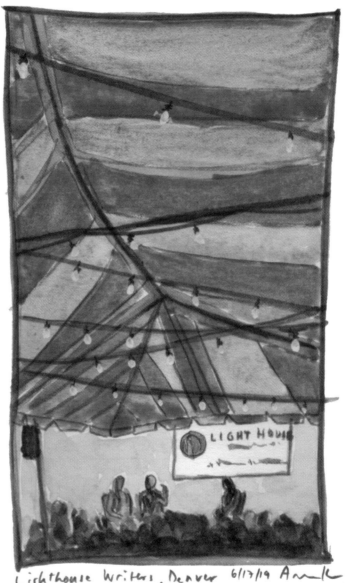

Lighthouse Writers, Denver 6/17/19 Armell
For Andrea, the host with the most!

Lighthouse Writers Lit-fest, Denver, Colorado, 2019

My most recent visit to Colorado was to teach a
non-fiction workshop. This visit was drug-free but I
fell under the magic spell of the writer Mary Ruefle,
who was teaching the poetry workshop for the week
I was there. Mary is the poet laureate of Vermont
and I knew her for her essay (or is it a poem? or a
poem-essay?) 'Snow' which begins with the words:
'Every time it starts to snow, I would like to have
sex.' 'Snow' won the Krause Essay Prize and I have
included it in the composition course on the 'essay
form' that I teach my first-year students. Her writing
is smart and idiosyncratic, plain and mysterious at
the same time; funny, cutting, and just extraordinary.
One of the ways in which you can quickly get
a sense of Mary's voice—though this method
would be shameful and lazy—is by finding on the
internet her short poem 'Red' in which she rewrites
the William Carlos Williams poem 'The Red
Wheelbarrow'. Another wonderful thing that Mary
does is that she produces what she calls 'erasure
books'. She takes old novels or books of poems and
puts most of the words on any page under erasure,
leaving just a few visible words that make their
own poetry. On some pages, she makes collages by
sticking small pictures that are always whimsical
and surprising. If Mary Ruefle's work has its own
sly voice, as a person, too, she is wholly herself. You
cannot email her. If you visit her website and click
on the contact button, you will read the following
line: 'Surprise! I do not actually own a computer. The
only way to contact me is by contacting my press,

Wave Books, or by running into someone I know personally on the street.'

Before I parted from Mary, I got her to give me her address in Vermont. I have sent her postcards by mail and received postcards in return. She also has a landline phone at her home and we have spoken once. I had invited her to come to my college to do a reading. She had agreed. But then the pandemic arrived. That is when I called her on her landline. Would she be willing to do a virtual reading if we arranged a meeting by Zoom? I offered this possibility and said that she could think about it. She didn't need to think about it. She said, 'I would rather die.'

Hudson river, New York, 2019

I was on the Metro-North train to New York City; I
was going to see my publisher, Sonny Mehta. A dull,
freezing cold day. There was ice on the Hudson river,
giant sheets cracking near the riverbank. I showed
my sketch to Sonny and he—always generous, always
kind—said I should do more of these. And I did,
sending him images from my phone, often with news
of cricket. I asked in a message one night if he was
watching Jadeja bat. Sonny wrote back immediately,
'Yes, with Scotch in hand.'

On the last day of that same year, on the morning of
31 December, I got a text from a close friend saying
that Sonny had died the previous night.

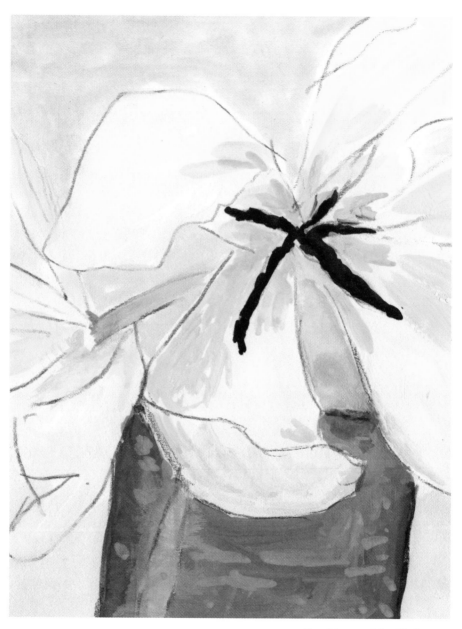

Poughkeepsie, New York, 2019

A friend brought these flowers, apologizing because they were dripping rainwater. I found them beautiful and blowsy, and wanted to paint them immediately before the petals dropped off.

The next day, I shared the painting with my writer-friend Michael Ondaatje. The flowers were a kind of a postscript. They were supposed to represent death where there was no blood. In my message to Michael, I had attached these flowers to another artwork and a brief report that you can see and read on the next pages.

Poughkeepsie, New York, 2019

My wife called me from her car. She was crying. She had been on her way to the pharmacy that is only five minutes away but something bad had happened. Driving on the dark road—it was late evening, night gathering all around, the glow of tail lights—she had struck a deer. She said she had been unable to react in time, and now she couldn't move in her seat. A man in the car behind her had stopped and asked her if she was okay. He then used his phone to call Animal Control. A woman slowed down to inform her—she was offering judgement—that the deer was suffering. My wife said nothing to her, but to me she said, 'It was a beautiful animal.'

After a while, she saw the Animal Control truck. She told me it had come to a halt behind her. Then she heard a shot, and she didn't want to talk any more.

When I sent Michael the painting and this account, he thanked me and said he had a story for me. A man driving in Dorset was stopped by the cops. He looked very disturbed. The cops grew suspicious and made him step out of the car. The man said that something had happened an hour earlier and he could not get over it. He said nothing more. The cops searched the car and in the boot they found a dead badger the man had hit and killed. He was still grieving. The driver was Ted Hughes.

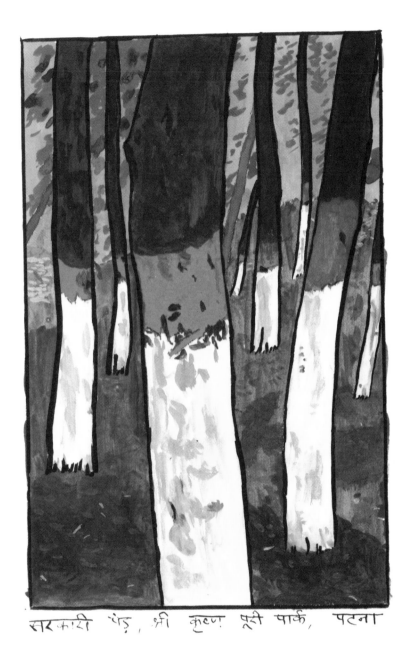

सरकारी पेड़, श्री कृष्णपुरी पार्क, पटना

Government trees, Shri Krishnapuri Park, Patna, 2019

Eight years ago, an editor called from Delhi to ask if I would write a short book about my hometown, Patna. I thought of the rats that had carried away my mother's dentures and said yes. But I was also thinking of myself as the rat who had abandoned his old parents. *A Matter of Rats* was published in India in 2013. The following January, my mother died.

I went home for the funeral. A fifteen-hour direct flight from New York to Delhi and then another, just over an hour long, to Patna, arriving at night. Hours after we had cremated my mother on the banks of the Ganges, my father opened her closet and laid out all its contents on the bed: beautiful silk saris, a couple of woollen coats, sweaters, small pieces of jewellery, a few gold coins.

My father proposed that my sisters divide the saris among themselves and close relatives. He mentioned the names of our aunts and a cousin who was sitting in the next room. The idea was a good one, but our grief was too raw, and my sisters protested by bursting into tears.

I watched in silence as my father turned his attention to the smaller items, the objects that, unlike the saris, didn't carry the smell of the perfume my mother had used.

The grandchildren were to share the three or four gold coins. I took two for my kids, whom I had left behind

in America. There were a couple of silver coins on the bed. One of them had the words 'Edward VII King and Emperor' embossed around the head of the bald, bearded sovereign. Had an old woman in my father's village given this coin to my mother when she had arrived as a bride?

I accepted unquestioningly the fine-looking sari that my father chose for my wife. Did I want anything from the items of jewellery? I shook my head to say no, but then picked up a necklace of prayer beads that I had seen my mother wear. This crystal necklace didn't look expensive and was light enough not to add to the burden of my sorrow. Take it, take it, my father said.

The name in Hindi for this necklace is 'spathik mala' and Google informs me that in English these are called rhinestones. The internet tells me that spathik 'cools the human body and mind' and that 'these crystals are also used for getting good luck and blessings from divine power'. I found all this out when I started writing this piece.

The truth is that in the years since my mother's death, this necklace has meant something else entirely to me. It is a reminder not of the divine but of the utterly human.

On the way to my classes in the morning, I sometimes touch the necklace where it sits near my mother's portrait. It is a way of remembering my mother.

My mother was a devout Hindu. She was also superstitious. On the first day of my class twelve exams, she summoned a priest to our house to conduct a lengthy puja. I didn't do too well in the English exam I took that day and always mocked my mother for her beliefs. I remember my taunts and her smiles when I touch the crystals.

Unlike my writing heroes V.S. Naipaul and Hanif Kureishi, I didn't have a father who was a failed writer. That role belonged to my mother. She often said that I had fulfilled her ambition. My piece about her death, 'Pyre', was published in *Granta* magazine and later chosen by Jonathan Franzen for *Best American Essays 2016*.

I might not be superstitious about these cheap crystals, but I am enough of my mother's son to believe that my success with 'Pyre' was her way of blessing me from the great beyond.

On the Ganges, Patna, 2019

My son, who was born in New York in 2009, doesn't speak Hindi—but I have taught him the first few lines of the Kishore Kumar song '*Hum to mohabbat karega, duniya se nahin darega*' (I'll dare to love, will have no fear of the world).

I have often explained to him the meaning of the words, but sometimes he asks in English: 'Baba, what does *duniya* mean?'

It means the world, *beta*, the world that I have lost. The world of Hindi.

I recorded my son singing the song when he was four and sent it on WhatsApp to my sisters who hadn't seen him for a very long time. I think they would be amused if they were to hear him say, when I'm putting him to sleep, '*Chupp chaap so jaao.*'

I have been living in the US now for most of my adult life. I had kept count as the years I had been away from India passed. But after fourteen years, I stopped. Exile had now turned to something more permanent.

The loss of my mother tongue is one of the consequences of this loss of home.

My Hindi is now like an old Ambassador car. It can still cover distances, but the speed isn't there. This old car of mine, even when it is working, makes a lot of unnecessary noise.

And the smoke!

The small town where I live is on the Hudson river. I often take the Hudson line train into New York City. There, in the big city, you'll be walking along and suddenly you will hear someone talking on the phone in Hindi.

'Nahin, nahin, Mamaji, aap kyaa baat kar rahe ho ... Baljit ke saath bhejta hoon. Aap meri baat suno ...' Even this kind of Hindi, which I associate with Delhi or Punjab, and not the tongue that I grew up speaking, is welcome to me.

I have never spoken to an Indian or Pakistani taxi driver in New York City in English. On occasion, if the driver is in the mood and I have the time, we'll have a long conversation in our shared language. It is a bit like sitting down and having tea together.

I realize I am being emotional. But here is why. Many years ago, when the magazine *Samkaleen Janmat* was being published from Patna, I used to have a regular column called 'Letter from America'. The people at the magazine would translate what I wrote in English and publish it in Hindi. I was moved by the translations. The realities I was describing, when presented in my mother tongue, became so much more immediate and sensual. I would read my own words, now in Hindi, and the hairs on the back of my neck would stand. Sometimes, I would cry.

I'm not trying to tell you about sentiment. I'm talking about language.

There is a very short poem by my friend Alokdhanwa, a poet who lives in Patna. In Hindi, how simple it sounds, how it rides straight into the heart!

रेल

हर भले आदमी की एक रेल होती है
जो माँ के घर की ओर जाती है

सीटी बजाती हुई
धुंआ उड़ाती हुई।

There are two ways to translate this poem from my native Hindi. One is this:

Rail

Every good man has a train
That goes towards his mother's house

Sounding its whistle
Blowing smoke.

And this is the second:

I have never forgotten this poem because of its beauty, and also because it is about trains. It reminds me of all the times I took the train to Patna when I was a student in Delhi. The joy of arriving home, seeing the look of happy surprise on my mother's face.

I later learned that the white flowers were "snow drops."

First signs of spring, Poughkeepsie, New York, 2019

I later learned that the white flowers were 'snowdrops'.

I have described the loss of my mother tongue. But the truth is that an immigrant also acquires a new language. It might not feel natural but it is still a gift. The first sight of snow falling. And a new word: 'flurries'. Then, years later, seeing these flowers push out of the snow when the thaw came. A neighbour said, 'Those are snowdrops.'

Writing a Novel

During an interview with a magazine in Mumbai,
I was asked what my biggest regret was.

When I think of my youth, I'm suddenly running
down a long, endless corridor. The sun is hot. It
sits still, bleaching the bones of the afternoon. The
running figure screams over and over again, 'What a
waste! What a waste!'

The interviewer then asked me what I was searching for.

Language. Language to name emotions, people, places.

Route 118, Alpine, Texas, 2020

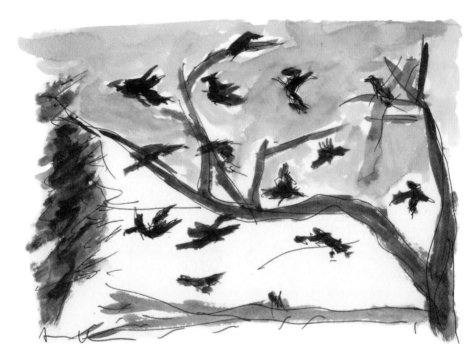

Crows, Poughkeepsie, New York, 2019

I was rushing to class, to teach, when suddenly
these crows appeared, wheeling and cawing outside
my window. Crows are not common in these parts.
We rarely see them. What were they an omen of? I
quickly decided that I couldn't go to campus without
attempting a sketch. I had just started my practice
of painting. It was new to me. I was using the
watercolour box that my son used in his elementary
school. Did I take five minutes or less to do this?
When people ask me about some of my favourite
pieces of writing advice, I always remember William
Maxwell's words: 'After forty years, what I came to
care about most was not style, but the breath of life.'
I wanted to catch life on the wing, as it were.

I wish I knew the names of all the birds where I live.
To write well you need knowledge that is specific.
When I was a young man in college in Delhi, I loved
going to Lodi Gardens and reading the names of the
birds painted on a rusting tin board. Who knew that a
titari was a red-wattled lapwing? So lovely. Or that the
kabootar was a blue rock pigeon and the kathphora
was a golden-backed woodpecker? But that the goraya
was just a house sparrow and the kouwa a humble
house crow.

You cannot be a writer if you are unable to name all
the trees in your city.

This knowledge about trees was another thing
I acquired and cherished during my walks in Lodi

Gardens. There are more than two hundred species of trees there. It was there that I learned that the botanical name for amaltas was *Cassia fistula*. Such fine music. That the peepal was *Ficus religiosa*. There were numerous signs for the tree called *Alstonia scholaris*, the botanical name for the saptaparni. I had read about the frangipani in W. Somerset Maugham's novels but never realized, until I saw the sign in Lodi Gardens, that it was the familiar but still very beautiful champa.

Ah, to write about the trembling of a single leaf on a beloved tree.

Or the fire of the dhak on the ridge near Hindu College. Rain glistening on the semul tree outside our house in Delhi. The silhouette of a giddh—the board in Lodi Gardens identifying it as a white-rumped vulture—on its highest branch. And my favourite, the gulmohar. I always think of the lines of Dushyant Kumar's ghazal: '*Jeeyein toh apni gali mein gulmohar ke talle / Marein toh gair ki gali mein gulmohar ke liye.*' Oh, to live in my own alley under the branches of the gulmohar, or to die in some strange alley for the sake of the gulmohar.

Blue Book, Poughkeepsie, New York, 2020

When I was a boy in Patna, my maternal uncle would have to invite for expensive meals a corrupt bureaucrat who handed out permits for my uncle's transport business. I went to a few of these dinners at the local restaurants. I was very young, eleven or twelve years old. My presence added a social, even familial, air to the whole event. The men could pretend that it wasn't a strictly commercial meeting, that there was no bribery involved. At one such dinner in a restaurant called Ambar, when I looked up, I saw pieces of broken glass bangles embedded in the ceiling. The curved pieces of glass were of different colours, and they reflected back the soft light in rich, pleasing patterns. At that age I wanted to write, and to describe things accurately; I realized during that dinner that I didn't quite know what to say about what I was seeing. Then, some months or maybe a year later, the school magazine, which was published like a newsletter and had the maths teacher as its editor, published an account by a boy I knew. He was a year older than me. In the story he had described that ceiling as a sky of broken bangles; the name of the restaurant Ambar translates from Hindi as sky. I was struck by what the boy had done. His success dazzled and intimidated me.

The ambition to write with precision and clarity faded for a few years and then returned when I was in late teenage. The opening line of Khushwant Singh's *Train to Pakistan* had an effect on me: 'The summer of 1947 was not like other Indian summers.' I liked

that the sentence remained direct even as it gestured towards a terrible history. It would take time for me to understand that strategically placed, seemingly simple sentences could develop into devastating drama. The writer who was a master at this was V.S. Naipaul. He often crafted a complex arrangement within the space of a single sentence. Nothing need appear forced or false. Here is a line from his *The Enigma of Arrival* that I chose nearly at random: 'To go abroad could be to fracture one's life: it was six years before I saw or heard members of my family again; I lost six years of their lives.' This was the work of an expert mason intuitively fitting bricks to build an elegant wall.

More years passed. In a book I was reading, I came across a piece of dialogue involving Naipaul. Upon being asked whether he liked any American authors, Naipaul had said, 'Do you know the first sentence of the short story "The Blue Hotel" by Stephen Crane? About the colour blue? ... I like that.'

I soon found the story in a library. This is its first sentence: 'The Palace Hotel at Fort Romper was painted a light blue, a shade that is on the legs of a kind of heron, causing the bird to declare its position against any background.'

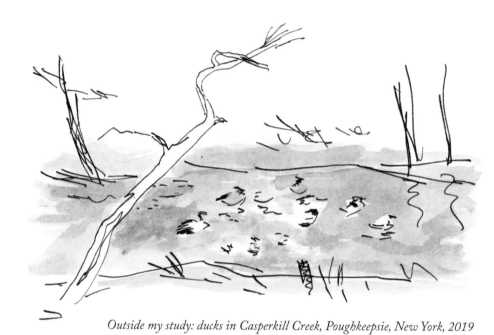

Outside my study: ducks in Casperkill Creek, Poughkeepsie, New York, 2019

When I moved into the house I bought a few years ago, across the road from Vassar College library in Poughkeepsie, the first thing I unpacked was my own little collection. On one small shelf I put books by John Berger, putting in the centre an anthology of his work, so that the photograph of a young Berger looked out on the room. Berger, at once a writer and an artist and a critic, was important to me: I had discovered him as an undergraduate in Delhi. No one else could be as political and sensual as he was in his writing. His books have been my companions for much of my adult life; *A Seventh Man*, his imaginative work on migrants in Europe, inspired my very first book, *Passport Photos*. His language hovered between poetry

and criticism; he was at once incisive and lyrical—a precursor to many contemporary writers who mix genres. On that same shelf beside Berger, I put books by writers I knew personally and admired—Michael Ondaatje, Geoff Dyer and Teju Cole—but also Joan Didion. I had never met Didion or Berger, so neither could be aware of this, but I had turned them into my mentors. 'The contents of someone's bookcase are part of his history, like an ancestral portrait,' the critic Anatole Broyard noted. I was trying to create a family album, accurate for who I was as a writer at that time in my life.

A couple of years ago, when I was on a book tour in Canada, I asked Michael Ondaatje to show me his Berger books in his Toronto home. I was seeking the family connection. Ondaatje said they were scattered in different parts of the house but here were a few on a shelf. I hadn't till then known of Berger's *Bento's Sketchbook*. It interested me at once—blood calling out to blood. Since then, scarcely has a day passed when I haven't attempted to draw like Berger does in *Bento's Sketchbook*. Scattered among his meditations on Spinoza are his drawings of irises, plums, a bicycle, a sketch of a fifteenth-century painting of a crucifixion. I am touched by Berger's attentive eye and his unaffected ease: wavering outlines drawn with pen and texture added by rubbing a finger wet with spit. This is what the books we adopt as our ancestors do: they give us permission to carry on doing the same.

Rio Grande river, US–Mexico border near Lajitas, 2020

In the summer of 2019, I stopped at a local pharmacy in New Hampshire and bought the day's newspaper. A photograph—of a drowned father and child, close together in death, the girl's arm over her father's neck—was on the first page. Tragedy at the border. The pair had made a difficult journey from El Salvador and then, after waiting in Mexico, decided to risk swimming across the Rio Grande near Brownsville. Valeria. That was the dead child's name. She was two years old and her father was twenty-five. The use of the photograph raised a storm: why are the poor, especially the conveniently dead, fit subjects for aestheticized horror? On this question, I find a painting sometimes more useful than a photograph.

A photograph is easily printed and reproduced and shared on social media. A drawing, on the other hand, is a more deliberate act. It slows me down. I do it in order to slow-jam the news.

The world comes to us in the form of bad news. I have used newspapers as my painting surface, using gouache to alter, change, transform what I had first encountered only as print. I asked my sister in Patna to mail me both Hindi and English newspapers that she gets at home and then I set to work in an attempt to regain a small measure of sanity. In one image of the Hindi edition, I saw girls playing Holi and, luckily, on the same page a photograph of the great writer Mahadevi Verma. I titled my effort 'Ladkiyaan Hain: It Is Spring, Girls Want to Play'.

Hindustan Times, *Hindi, Patna, 2019*

Poughkeepsie, New York, Day 55, #coronavirusdiary, 2020

Politics, especially after Trump, is like the elephant in the room in a poem by Kay Ryan. (It is the same with dictators everywhere.) The elephant takes up so much room, says Ryan, that there is no room to talk about it. Your writing can be political—I would even argue that it must be political—but politics even in art is like the elephant in the room. A part of me feels that the purpose of art is to open up a space that is, at least for a while, free of politics. That feels like freedom. Perhaps for that reason, we writers often let our eye linger on small, seemingly irrelevant details. We can be reading about a riot but will have noticed that the murderer holding the knife has the nail on his pinkie painted red.

Valentine, Texas, 2019

'From a very early age, perhaps the age of five or six, I knew that when I grew up I should be a writer.' That is the first line of George Orwell's famous essay 'Why I Write'.

I was already sixteen when I read those words. I also wanted to be a writer. When one is young, one wants to be many things. The ambition lasted a few years and then I turned my attention to other pursuits. Later,

this ambition came back stronger. There was a reason for this: when I was older, I had more things to write about, and it became easier to write.

So, that's the first thing I need to say here: writing begins with waiting.

When I look at the diaries I kept in my late teens, they are full of passages copied from the books I was reading. I'm struck by the fact that there are so few observations in those pages about the outer world. Was it warm that day? Did it rain? How much did I spend on tea at the chai-wallah in the university? Did I overhear an interesting exchange in the bus? I'm disappointed that I get no picture from those early diaries of a writer in the world.

That is the second thing I need to say here: if you have nothing to write, observe the world and record its ways.

When I first read the Orwell essay in a classroom in Modern School, Barakhamba Road, I didn't fully understand it. He begins by saying that the sound that words made were of interest to him. This puzzled me. No one had told me about this and I felt I was lacking in any real talent. I had a better grasp of the four main reasons Orwell gives for writing: 1. sheer egoism; 2. aesthetic enthusiasm; 3. historical impulse; and 4. political purpose. And yet, these reasons remained abstract—I couldn't quite understand how I could put them into practice.

All of that would become clearer in time. It has never not been a struggle. The kind of diaries I have kept over the last two or three decades have helped me write all my books. They are stuffed with cuttings, details of conversations, notes scribbled down about future projects, ideas for plots and, for the past several years, logs about daily writing (a small tick mark to indicate that I have done the day's quota).

That is the main thing I need to say here: a diary is an essential part of writing. This book that you hold in your hands is both a diary and a work made up of diary entries.

Whenever faced with an open or uninhabited or empty-seeming country, I conjure a stranger in a story. On occasion that stranger is me. I start thinking of a story to tell. Behind all this speculation is a dictum that is attributed to the late John Gardner: 'There are only two plots in all of literature: you go on a journey or a stranger comes to town.'

2/5/20

I woke up and checked to see if my agent had written with any news. Will there be any — soon?

I've followed a daily routine of reading, writing, a drawing, and a visit to the gym. But with the question uppermost in my mind, the story is looking for a (happy) ending.

2/6/20 No word from Godwin. I asked David Means to read the opening pages in case I need to correct something. I wrote and went to the gym in the morning; came back and painted this scene below. Finished rereading Train Dreams and will start on it again tomorrow. I should finish reading Lerner tonight.

Marfa, Texas, 2020

An author asks fellow writers to inscribe their books with a pithy piece of guidance.

It has been nearly 20 years since the night in a newspaper office in Delhi when I came across a copy of a fax V. S. Naipaul had sent in response to a reporter asking for his rules of writing. ("Avoid the abstract; always go for the concrete.") I found those rules useful. In recent years, I have had a mantra of my own: "Write every day, and walk every day." A modest goal of 150 words daily and mindful walking for 10 minutes.

I suspect writers are more likely than, say, firefighters or doctors or second basemen to seek professional advice from those they admire. This is because writing is regarded as a magical act, its mysteries parted, if only temporarily, by the adoption of some practical rules about point of view or the use of revealing details. The truth, of course, is that writing is a wholly individual, idiosyncratic practice. When I started asking writers I knew or met at literary festivals to sign their books with a piece of valuable advice, I began to see it not as self-help but, instead, as a glimpse into that particular writer's mind.

Having asked dozens of writers this question, I have now arrived at what I myself want to inscribe in the books I'm asked to sign: "Language is your closest ally and if you align it with your desire for freedom, you will be able to live forever."

Read the masters and, at least occasionally, read them closely!

Show, tell, is of no use—only writing.

"I don't know what to prefer the beauty of inflections or the beauty of innuendos. The blackbird whistling or just after ..." — WALLACE STEVENS

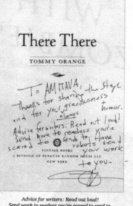

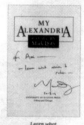

There are always more than one story. Your job is to find that story you did not start to tell.

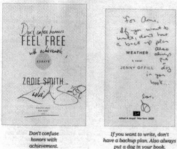

Don't confuse honors with achievement.

If you want to write, don't have a backup plan. Also always put a dog in your book.

Advice for writers: Read out loud! Send work to readers you're scared to send to. Have robots read your work to you.

Learn what advice to refuse.

AMITAVA KUMAR is the author of "Every Day I Write the Book" and the novel "Immigrant, Montana."

From The New York Times Book Review, *14 August 2020*

It has been nearly twenty years since the night in a newspaper office in Delhi when I came across a copy of a fax V.S. Naipaul had sent in response to a reporter asking for his rules of writing. ('Avoid the abstract; always go for the concrete.') I found those rules useful. In recent years, I have come up with a mantra of my own: ' Write every day, and walk every day.' A modest goal of 150 words daily and mindful walking for ten minutes.

I suspect writers are more likely than, say, firefighters or doctors or accountants to seek professional advice from those they admire. This is because what we are able to do on the page is regarded as a magical act, its mysteries parted, if only temporarily, by the adoption of some practical rules about point of view or the use of revealing details. The truth, of course, is that writing is a wholly individual, idiosyncratic practice. When I started asking writers I knew or met at literary festivals to sign their books with a piece of valuable advice, I saw it not as self-help but, instead, as a glimpse into that particular person's mind.

Here is some of the advice they shared with me when they inscribed their books for me:

'Read the masters and, at least occasionally, read them closely!' (Lydia Davis, author of *Essays One* and other books)

'There is always more than one story. Your job is to find that story you did not start to tell.' (Yiyun Li,

author of *Dear Friend, From My Life I Write to You in Your Life* and other books)

'Advice for writer: Read out loud! Send work to readers you're scared to send to. Have robots read your work to you.' (Tommy Orange, author of *There, There*)

'Don't confuse honours with achievement.' (Zadie Smith, author of *Feel Free* and other books)

'I don't know what to prefer, the beauty of inflections or the beauty of innuendoes. The blackbird whistling or just after ...' (Wallace Stevens, quoted by Colum McCann, author of *Thirteen Ways of Looking* and other books)

'Show, tell, is of no use—only writing.' (Jamaica Kincaid, author of *A Small Place* and other books)

'If you want to write, don't have a backup plan. Also, always put a dog in your book.' (Jenny Offill, author of *Weather* and other books)

'Learn what advice to refuse.' (Mark Doty, author of *My Alexandria* and other books)

Having asked dozens of writers this question, I have now arrived at what I myself want to inscribe in the books I'm asked to sign: 'Language is your closest ally and if you align it with your desire for freedom, you will be able to live forever.'

In each notebook for every book that I have worked on, I put photographs or drawings of my children. It is a superstitious act born out of the belief that love will save me. Human shields.

If you look at my notebooks, they are a record not just of my writing but of my children growing up. Another kind of photo album.

Also from an interview that I gave to a magazine:

Q: What has been your biggest extravagance?

A: That island in the Pacific. It was an expense I could hardly afford. No, I'm kidding. I love my children to wild excess. I won't lie: it seems a form of indulgence at times. But it has yielded the greatest joy.

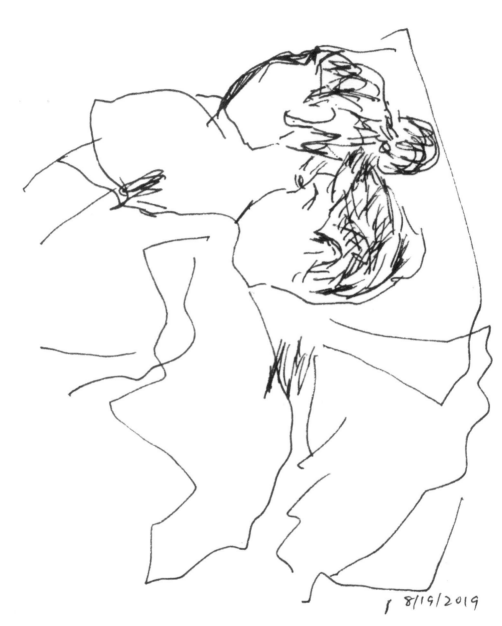

8/19/2019

In a motel room in Pacific Grove, California, 2019

Snow suddenly swarmed outside and my tired
mind, seeking a pattern, began to think of rumors.

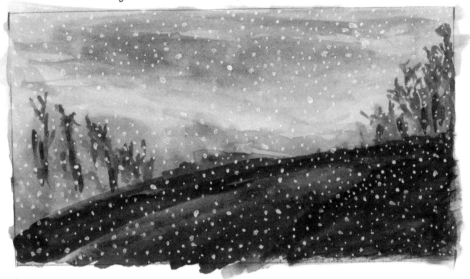

I-84 W, returning from New Haven, 2019

But why should snow, swirling outside your car, make
you think about rumours? Because for the past few
years, I had been working on a novel about truth and
lies. In *A Moveable Feast*, Hemingway provides this
advice: 'All you have to do is write one true sentence.
Write the truest sentence you know.'

With the rise in fake news and right-wing populism, I
reversed Hemingway's dictum. Every day I was going
to jot down one revealing lie. This had now become
my obsession.

Gouache and ink on newsprint, Poughkeepsie, New York, 2019

Did I begin writing my novel with a desire to mock what was irrational and laughable? It is possible.

On his retirement from the Rajasthan High Court in 2018, a judge said that the peacock, the national bird, was 'pious'. He described the peacock as a lifelong celibate creature. Instead of mating with the peahen, the learned judge said, the peacock sheds tears. The peahen gets pregnant by swallowing the tears of the peacock. It was for this divine reason that Lord Krishna wore a peacock's feather on his head.

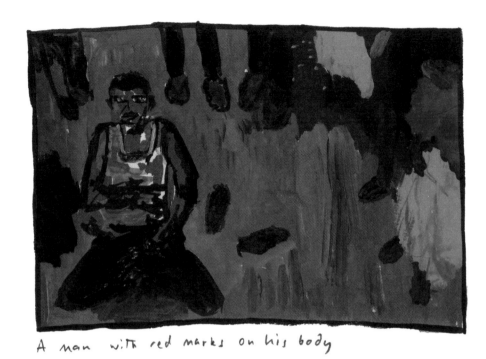

A man with red marks on his body

From a photograph in Hindustan Times, *2019*

Or did the writing begin because of something more brutal?

For this painting, I worked from a photograph in the *Hindustan Times* of 22 May 2017, showing a man kneeling in the dirt, begging for his life. Half of his white vest—and his face—is soaked in blood. He is surrounded by onlookers—we see their legs, not their faces. The man on the ground, who has not been lynched yet but will be soon, is Mohammed Naeem. He is suspected of being a kidnapper. He is asserting

his innocence, because that is the truth, but it is already too late for the truth.

In making a painting from a photograph in the newspaper, I was trying to look at the scene more closely. And perhaps make others do the same.

Mohammed Naeem, whose photograph moved me to paint him, was lynched near Jamshedpur. Even before Mohammed Naeem's death, in the same state, Alimuddin Ansari, a Muslim meat trader, was pulled out of his van and beaten. His van was set on fire. Ansari died on the way to the hospital. One of the main accused in the case was the man in charge of the ruling party's media operations. When the eight men arrested for Ansari's killing were released from jail, in July 2018, the Harvard-educated politician who was the local representative of the ruling party put marigold garlands around the necks of the accused men and fed them sweets. (*The New York Times*, in its report on the incident, called 2018 'the year of the lynch mob in India'.)

I had a personal connection to the politician who had garlanded the killers. I went to school in Patna with him. He was my classmate till the tenth standard and we played tennis with each other. Once, during a hike near Mussoorie, where we had gone together to represent our state in tennis, I had caught hold of the teenager he was then to prevent him from falling down into an abyss.

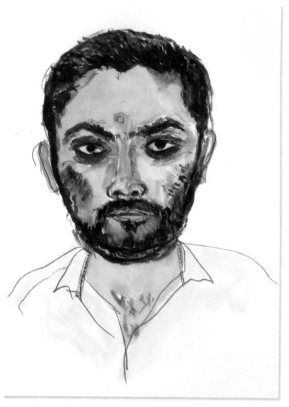

Parshuram Waghmare, 2019

I spent one morning sketching the image of
Parshuram Waghmare, the killer of the progressive
journalist and activist Gauri Lankesh. Did I feel any
closer to Waghmare or understand his motives because
I was slowly drawing him? I should confess that I
didn't. In fact, all I did was produce portraits that
resembled identikit images put out by the police in an
effort to catch criminals. According to news reports,
Waghmare, a twenty-six-year-old utensils salesman,

was paid ten thousand rupees to shoot Lankesh. All he had been told was that he had to kill someone to save his religion. Right-wing Hindu groups raised money for the murderer's defence and also defended Prime Minister Modi's silence on Lankesh's murder. One leader asked, 'Do you expect Modi to respond every time a dog dies in Karnataka?'

In her final editorial before her death, Gauri Lankesh wrote: 'I want to salute all those who expose fake news. I wish there were more of them.' When I read that, I felt that I was doing the right thing by writing my novel. I also learned that of the ten thousand rupees that he was paid for the murder, Waghmare had used four thousand to pay for a medical procedure. There had been a problem with his nasal passage and he had required surgery. Did I think that a human detail had now become attached to Waghmare? Yes. I believe it is for this reason that defence attorneys here in the US point to their criminal clients and inform members of the jury that the defendant, before the injury to his leg, had enjoyed playing baseball with his young sons. (The reporter on that story, for his part, revealed something of the human too—for is it not human to exaggerate and lie, particularly if you are a tabloid journalist?—when he planted the following lead: 'After shooting Gauri Lankesh, Parshuram Waghmare got a nose job done with the money paid to him for the murder.')

Postcards from the Pandemic

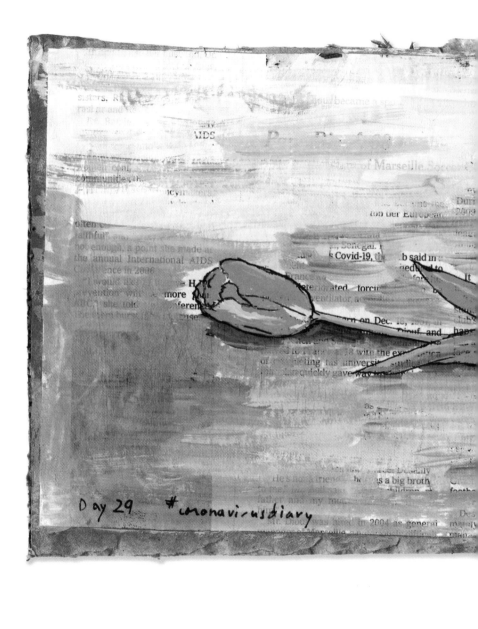

Day 29 #coronavirusdiary

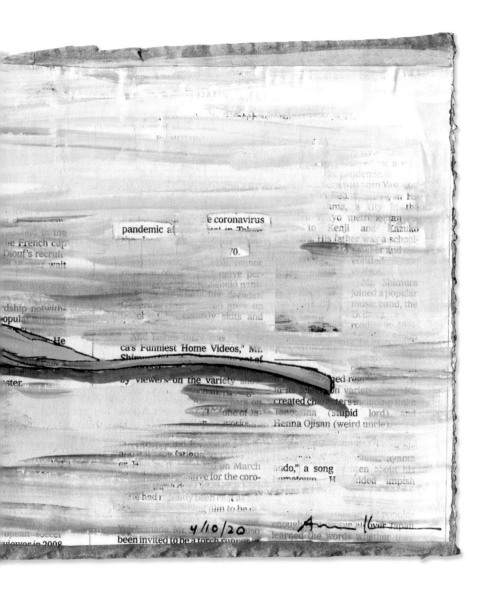

Gouache and ink on newsprint, Day 29, #coronavirusdiary, Poughkeepsie, New York, 2020

Why was I writing a novel about the news? I had read a statement by John Updike somewhere that the novel had traditionally held up a mirror to the Western bourgeoisie, teaching its members how to shave, dress and behave. But I knew how to shave; what I wanted was to make sense of what was happening in the outside world, a world of WhatsApp rumours and hateful lies. 'Novel' is derived from the Latin 'novella', another word for what is new or, as I understand it, in the news.

While I was working on my book, we heard about a dangerous virus. And then, very soon, the pandemic was upon us. Disoriented by all that was known and unknown, I kept a journal where I recorded my confusion. It was spring, tulips were blooming outside my window, and everywhere there were reports of mounting deaths. When *The New York Times* published notices about those who had died from Covid, I used the obituary pages to paint flowers.

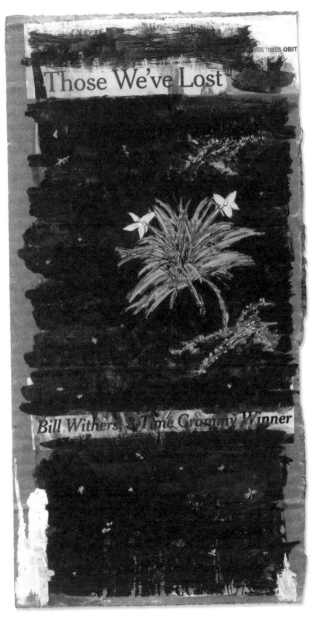

Gouache and ink on newsprint, Day 48, #coronavirusdiary, Poughkeepsie, New York, 2020

In late February 2020, on a chilly evening in Tivoli, upstate New York, I was in a conversation on stage with Jenny Offill to celebrate her novel *Weather*. Lizzie, Offill's narrator, is a librarian who does research for a mentor's doom-laden podcast about climate change, and whose dire observations are often about disaster psychology and survivalist strategies.

At the end of our conversation, Offill read aloud this little section from her book titled 'What to Do If You Run Out of Candles':

> A can of tuna can provide hours of light. Stab a small hole in the top of an oil-packed tuna can, then roll a two-by-five-inch piece of newspaper into a wick. Shove the wick into the hole, leaving a half inch exposed. Wait a moment for the oil to soak to the top of the wick, then light with matches. Your new oil lamp will burn for almost two hours and the tuna will still be good to eat afterward.

This fragment haunted me during the first days of our enforced isolation. I hadn't shown any foresight, hadn't stored any food. At the local grocery store, many of the shelves were bare. No chicken, no canned soups, no beans. Not even tofu, which baffled me for some reason. And certainly no wipes or gloves. I bought several cans of tuna. I was sure I had newspaper at home that I could fashion into wicks. That was my emergency plan.

Later, on Twitter, I saw a tweet about a sign at a drama school: wash your hands like you convinced your husband to murder the rightful king and you can't get the blood off.

A part of my pandemic journal was published in *The Indian Express*. Two headlines had caught my attention during those early days: 'In Lockdown Desperation, Migrants Pick Bananas Trashed Near Delhi Cremation Ground' and 'Zoo May Feed Animals to Animals as Funds Dry Up in Pandemic'. And this piece of awful news from a list compiled in *Harper's*: 'A woman who died alone in a nursing home recorded over 40 messages on an Alexa, many of which asked the device to relieve her pain.'

Gouache and ink on newsprint, Day 34, #coronavirusdiary, Poughkeepsie, New York, 2020

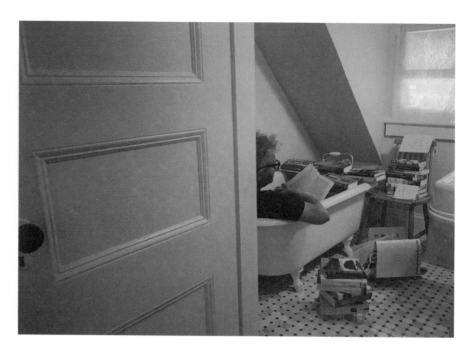

Self-portrait: reading literature during the pandemic, Poughkeepsie, New York, 2020

For writers, the enforced isolation wasn't unusual (and, for some, not even unwelcome) but what I had been inhabiting, like the rest of the planet, was the general feeling of disorientation. I was extremely fortunate; I had been spared acute distress. Mine was a portrait of privilege. Hence, in this image, the pose of leisure, the body in the bathtub. But things were also crazy. Even in the smallest acts the sense of dislocation of what was once normal. Of things being unusual or even out of joint. The body in the bathtub is clothed, there is no bath water, only books.

In a bid to control the pandemic, the Modi government imposed a brutal lockdown. This meant that millions of poor, starving migrant labourers and their families were left to find ways to return to their villages. They were trekking hundreds of kilometres on highways and railway tracks.

A photograph appeared on my Facebook page—it was taken after an accident on a railway line on 8 May. At least sixteen workers who were sleeping on the railway tracks during their long trek home, had been killed. To avoid the police who would have harassed them on the highways, they had been walking on the train tracks. There was a national lockdown, and no trains were running—or so they thought. At night death came in the form of a freight train.

The first item I noticed in the image was a red Hawaii chappal. I think abandoned footwear tell their own forlorn story. A solitary chappal or shoe narrates a tale of hasty exit—not from a glitzy ball, like fair Cinderella, but from life itself. A grim reminder that one was never invited to the world's royal gala.

Then I saw the rotis scattered on the cinders lying on the ground. A lemon. One blue mask, now useless. A pair of black trousers—but no, there was also a torso attached to it, only partially hidden by the green leaves that someone must have pulled from a nearby field to cover the dead.

I'm sure that none of the dead, who had only been
trying to get home, had any money on them. So, no
currency notes fluttering in the breeze. There must
have been in one or other of the pockets an Aadhaar
card or a ration card. A photo of a child or a wife left
behind in the village where they were now headed.
A tiny passport photo which is the shallowest grave
a person can find to bury the story of a whole life that
never makes it to the news.

But I couldn't see any of those things in the image
that had arrived on my phone. Only the train tracks
meeting in the distance, as if they had reached their
destination. But that too, as any schoolchild knows
from science lessons, is an illusion.

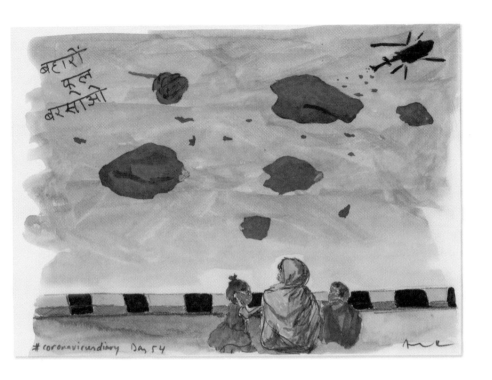

I painted this image in the form of a montage. A newspaper photo of a migrant family stranded by the roadside; and another news image of rose petals being dropped from the sky at the government's orders to honour medical workers.

Day 54, #coronavirusdiary, 2020

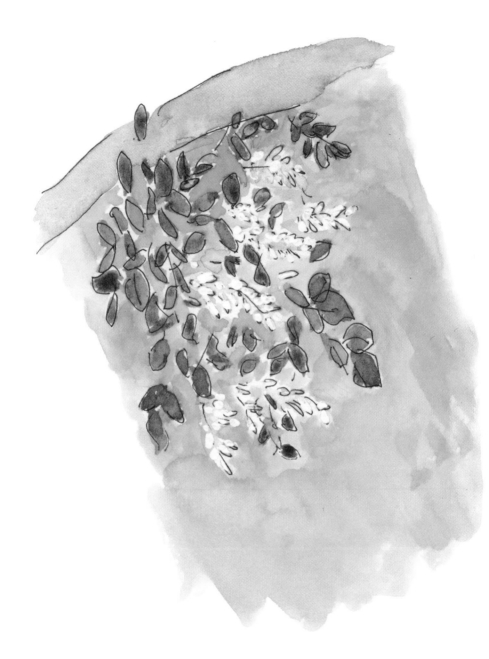

Yellow-wood, Poughkeepsie, New York, 2019

The yellow-wood in our backyard is my wife's favourite. It did not flower in the summer this year and my wife wondered if somehow the pandemic had also had affected nature. I didn't think she was serious but I was concerned. I had very much liked the white, fragrant flowers that I had painted in late May the previous year. When I searched online I learned that the yellow-wood puts out its flowers only every second or third year. This surprised me. Had I noticed the flowers the previous year only because I had painted them? And had I never been conscious of their absence before? I realized that when my wife complained that the tree hadn't put out flowers this year, I went to my Instagram to check when I had last seen the flowers. Turned out it had been on 29 May 2019. I was going away to Yaddo and I had just finished reading Richard Powers's magnificent book *The Overstory*.

In the early days of the pandemic, I had read a news article that said during the lockdown people had been drawing their pantry. I drew what I could see outside my pantry window: just outside our screened porch, a forsythia bush ablaze with colour in the morning light. Then, more weeks passed. My wife bought online these light white tables that she put out on the porch and then strung large fairy lights overhead. I painted this picture after seeing my wife and daughter sitting outside, chatting after dinner. In it, there are two small tables pushed against each other: the reasoning behind it being that if a friend came over for a drink, we would ensure we remained six feet apart.

It is impossible for someone to look at this painting and remember that so much had happened in the preceding months: the deaths from the coronavirus, the suffering of the tens of thousands of migrant workers trying to return home after the hasty lockdown imposed by the Modi government, and in the US, the widespread social ferment over repeated instances of police brutality. For my part, I cannot look at this image without thinking about what I was doing on those days and nights: for at least an hour or two every day, I would shut the world out and work on my novel. 'In the age of social media,' a newspaper reported, 'misinformation spreads a thousand times faster than the virus.' I learned that the WHO believed that we were confronting an 'infodemic'. In the pages of my novel, I was asking: what is the role of fiction in these times? What can literary fiction do in the face of the fiction that is fake news?

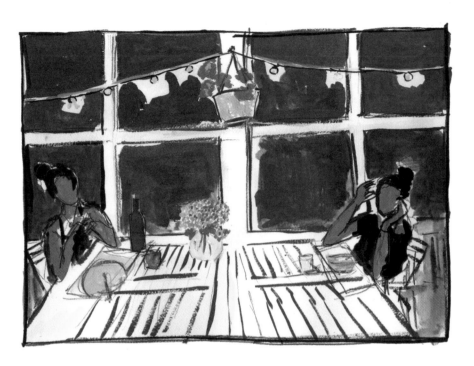

Porch night, Poughkeepsie, New York, 2020

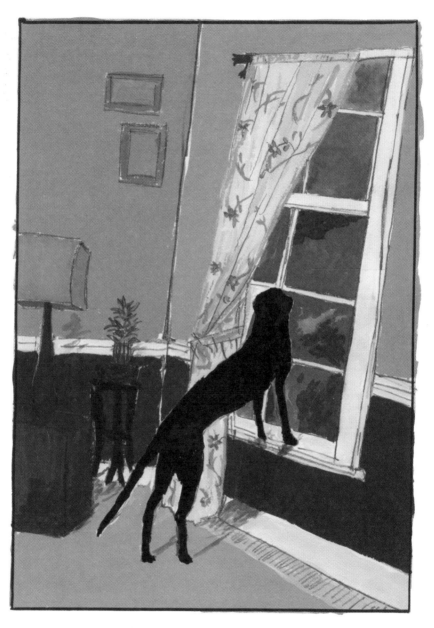

Pebble, Fairfax, Virginia, 2020

My niece and her boyfriend, their dog in tow, came to stay with my sister during the lockdown. No one went out. But if anyone did, the dog kept vigil, alert, waiting.

We were all waiting. We were waiting for things to be all right. And one day, they will indeed be all right. But the dead will never come back. We mourn all the people who died, and who will still die, because of this disease and the foolish arrogance of our leaders. The businesses that have closed and will not reopen; the dreams dashed; the families and relationships that could not withstand the strain. This is why it is important to note down all the changes in our lives. Write them down in a journal. When we do that, we are recording our own history.

As the disease spread, I was good about keeping a journal, meticulously taking down notes about the news. Increasingly, however, this became a burden. I wanted to write something that required an exercise of my own imagination. Then, one day, out of the blue, an idea came to me. I sat down to write a very short story, less than two hundred words long. It seemed a weight had lifted off me, the weight of the pandemic. I had titled my story 'Essential Services'.

Essential Services

Every day that week, a line formed outside the liquor store by noon. Those in queue stood six feet apart, checking their phones, or reading a book, or looking up at the trees. Twelve people were allowed inside at a time.

A man and woman, wearing masks and gloves, arrived from different directions. The man, who might have been in his twenties and whose mask was blue-coloured, made a flourish with a gloved hand and let the woman take the place ahead of him. For a moment, he studied the back of the woman's head. She had blonde streaks in her hair.

'You weren't answering the phone last night,' the young woman said to him, turning. 'Do you think it is easy for me to step out like this?'

Her companion hadn't stopped smiling under his mask ever since she arrived.

He now said, 'I've heard that the wait is longer in the line outside the CVS on South Hill Road. Your father must need his medicine. Let's meet there tomorrow.'

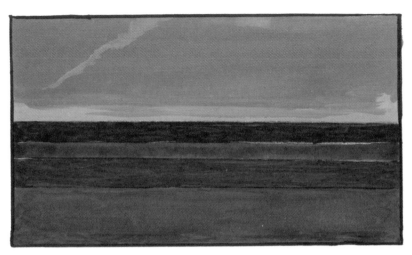

Newport, Rhode Island, 2020

Ah, the sea! When the travel restrictions were lifted, I drove my family to a beach in Rhode Island. We were required to practice social distancing, and we did, but there were many who weren't following the rules. It was strange to see people not behaving responsibly. Rhode Island would later become one of the states with the highest per-capita coronavirus cases. It was also strange to once again do things that had been routine before, for example, stepping into the elevator.

I had heard that many people were reading the novel *The Plague* by Albert Camus. I thought of Camus while I was at the beach. In the middle of the pestilence, the doctor in the book, Bernard Rieux, and his friend Jean Tarrou go for a swim in the sea. They are mindful of the pain around them but they also hang on to life. Camus says that theirs is 'a happiness that forgot nothing'.

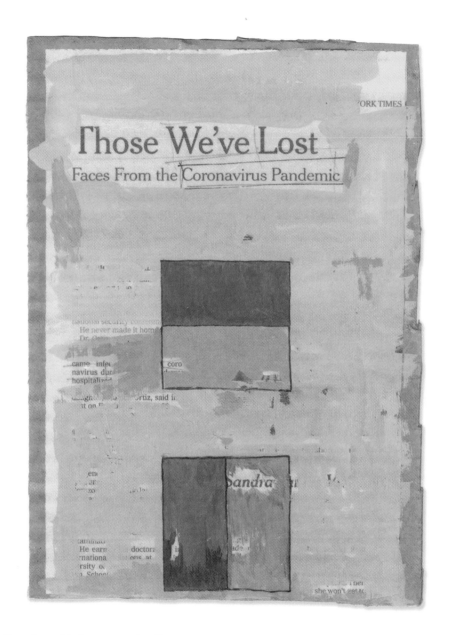

Gouache and ink on newsprint, Day 34, #coronavirusdiary, Poughkeepsie, New York, 2020

In late November 2020, I got a call from Florida, where I had my first job. I knew a graduate student who, during the twenty years or so since I had left the state, called me on my birthday. I did the same for him.

It was his birthday a week ago. I had called him and left a message. Then I had sent him an email.

The call on that November afternoon was from a woman who said that she had got the manager of the building to open the door to my friend's apartment and they had discovered that he had been dead for some time.

When a body is found like this, the police treat it as a homicide to make sure that there is no foul play. The caller said she didn't know if his death was from Covid. I wasn't sure either—we didn't need the virus to teach us about human loneliness.

We talked a bit, this stranger and I, who said she had met me in my friend's parking lot all those years ago. We talked about my friend. We cried a bit. And said we would stay in touch.

I was writing a note to my friends at my old job, telling them about this student we had, when the phone rang again. I thought it was the woman who had called earlier.

A private number. It was a child's voice on the other end. After some hesitation, the voice said something obscene, a sexual invitation.

I was so full of sorrow—and love, really—that my customary curses abandoned me. Instead, I found myself giving the kid calm advice.

I think my friend would have liked this story about the two calls.

Goodbye, Tom.

Gouache and ink on newsprint, Day 76, #coronavirusdiary, Poughkeepsie, New York, 2020

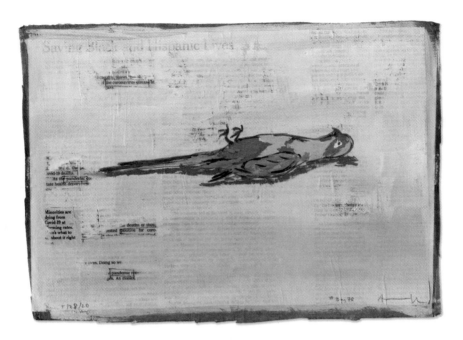

Gouache and ink on newsprint, Day 76, #coronavirusdiary, Poughkeepsie, New York, 2020

I had a little bird
Its name was Enza
I opened the window
And in flew Enza

*A ditty sung by children in Philadelphia
during the flu pandemic of 1918*

I painted them this morning.
Where did I first see tulips? In
Srinagar, in Kashmir, where now death

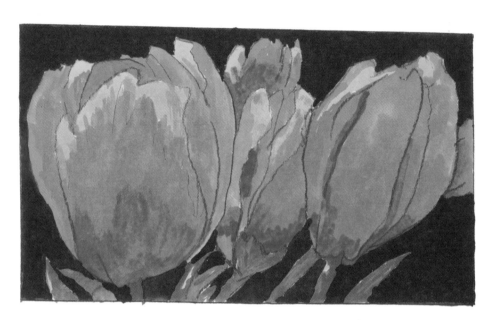

blossoms like flowers. Endless rows
of gravestones. We live in toxic times.
Everything is poisoned. I paint a tulip:
I also think of Trump.

Tulips, Poughkeepsie, New York, 2019

This is what the pandemic forced me to do at its darkest. It made me want to imagine other days, brighter days. And it forced me to ask how I would write about change.

In India, just before the coronavirus arrived, there were protests against a new law that discriminated against minorities. Even old women huddled against the cold, sitting out at Shaheen Bagh. And in the middle of the pandemic, here in the US, there were protests against police brutality. A society that was under siege because of the coronavirus erupted in solidarity with Black citizens.

I continued work on my novel in fits and starts. This is what I wrote in it about social change:

> When I was a boy in my hometown and it had been raining for three days, it became so that it was no longer possible to have any consciousness of a time when it wasn't raining. Rain soaked through the walls and slime grew on the inside, in the corners, and even on the ceiling. Phones stopped working. No newspapers came. Birds disappeared from the wet branches of trees. No question of going to school. There was no language outside of 'It is raining outside.' Water stood in the distant fields. It rushed down pipes and roared in the gutters. The roads became rivers in which people waded or swam. Brij Bihari brought his cows on to the veranda at the back of our house. Mother would switch on the fans

in one room to try to dry the wet clothes. It was all in vain. The snake found in the toilet was proof that the world outside had changed, and the natural order had been turned upside down. Only rain was permanent. You could do nothing but wait. I'm saying all this because that is exactly what has happened to us politically. We cannot imagine—I cannot imagine, sometimes—a time outside this time. The people who are in power must also be deluded enough to believe this. They must think that their power is eternal. That they will sit on the throne forever. And it is this thought that is their failing, because it condemns them to missteps and errors. Stay alert. You will hear the rain stop and the wind shift. The powerful will not be waiting for it but that moment will come. It will mark the beginning of their doom, their end.

A writer-friend was working on a film project. He wanted me to send him a brief video. Dozens of people were being asked, he said, to do this. You were supposed to begin by saying the words 'Two truths and a lie', and then tell two truths and a lie in any order. Of course, you were not to say what the truths were or what the lie was. The subject matter was left to the person making the video. The project aimed to make the viewer examine how we know what we believe.

At first, I thought I would do something about Trump. I would present three outlandish, outrageous things. All the three statements would be absurd and strike the viewer as either all true or all false. This would be a commentary on the mad times we have been living through.

But that is not what I did.

I filmed myself in my library saying the following:

Two Truths and a Lie.

My eighty-six-year-old father died from complications due to Covid in March 2020.

I'm writing a novel now about my father.

The novel's title is *My Beloved Life*, the phrase borrowed from a poem by Louise Glück: 'death cannot harm me / more than you have harmed me, / my beloved life.'

One tree says it is spring, Poughkeepsie, New York, May 2019

I sent the video to my friend who wrote back to offer
condolences in case it was indeed true that my father
had died. It wasn't. I had given voice to my fear during
the pandemic. My sisters and I worried incessantly
that he would fall sick. Even as I spoke that lie for the
video, I was worried that just by uttering it I was going
to make it come true.

As a child, I often rehearsed the eventuality of my
parents' deaths. I suppose it was a stand against fear.

When I was older the fear went away for a while. It returned when my parents grew older, and I began to write about death.

Over the last few months, I have indeed started making notes for a book that covers a time period that fits the arc of my father's life. There were so many lives lost during this pandemic. And the question that came to me was: how to honour ordinary lives? Isn't any ordinary life, or what we might consider an ordinary life, full of strange happenings, surprises, moments of unimaginable joy or grief?

There were a few details that I took from my father's life: a fox trying to drag away his baby sister in the village, his journey from rural Champaran to Patna to study, his crossing the Ganges on the ferry to reach Patna, and sleeping on the bank of the river on his first night near the college he would join the next day. Everything else was invented. What I am saying, then, is that another lie was the statement about writing a novel on my father. The reality was that I was inventing a life.

Had I lied, then, to my friend in my video? Isn't that what writers do? Yes. And yet, and yet. When have I not struggled to reach the most essential truth? In the notes I was making about the death in Patna of an eighty-six-year-old man from the coronavirus, I was imagining my sisters' grief. I was searching for what is more real than the familiar distinction between truth and lies.

Shadows on the snow,
Poughkeepsie, New York, 2020

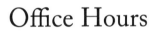

Office Hours

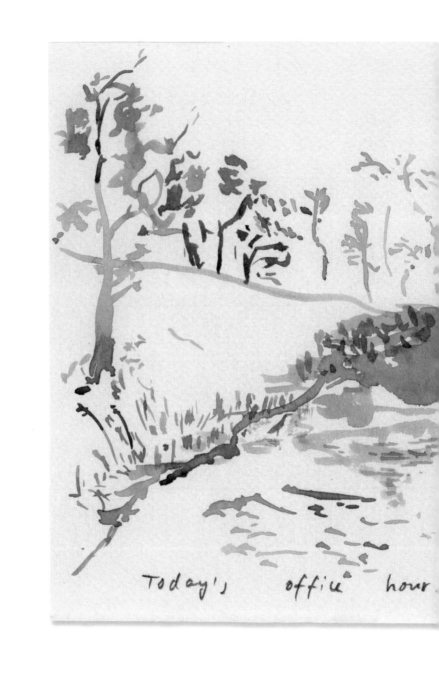

Today's office hour.

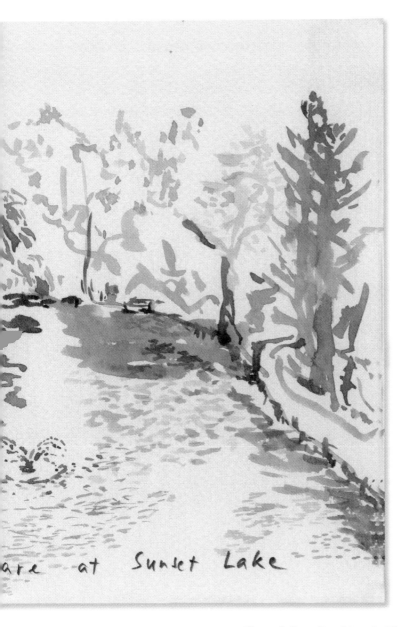

are at Sunset Lake

Vassar College, Poughkeepsie, New York, 2020

Fall semester, 2020. How to prepare for a semester during which some of our students were unable to return to campus because of Covid? I thought my classes should have writing prompts about the pandemic. Even before the students arrived on campus, I sent them a link to an article in *The New York Times* titled 'The Quarantine Diaries'. This article said that journal entries and drawings from all over the world were offering us 'a history of the present moment'; it quoted Jane Kamensky, a professor of history at Harvard, as saying: 'Diaries and correspondences are a gold standard. They're among the best evidence we have of people's inner worlds.'

Even in what we now—post-Covid—call normal times, I would be walking to my office in Sanders Classroom and look at my watch. Fifteen minutes left before office hours begin? Let me take a stroll around Sunset Lake! During the pandemic, I have been teaching outdoors under tents. Tent no. 1, close to Rockefeller Hall, and Tent no. 7, next to Chicago Hall. A few students are attending class remotely, from places as far away as Brazil and China. On occasion I'll turn the Zoom camera around to show those students what our beautiful campus looks like at that hour.

The essence of creativity is to imagine new possibilities even in adversity. Outdoor classes under tents, the wide-angle camera on a tripod that shows our remote students their classmates sitting on desk-chairs six feet apart, the antiseptic wipes we use to disinfect the

surfaces we touch are creative responses to a problem we are all facing together as a community.

The pandemic has resulted in hundreds of thousands of deaths in the US and has devastated families and the economy. I have been able to take note of the positive, healthy, even euphoric, effect that their return to Vassar has meant to our students. They are glad to be with their friends and attending classes. During my walks on campus the last few evenings, I have seen them sitting under the tents where I teach. The lights are on. It is a pleasant sight, young people having socially distanced dinner from take-out containers, or wearing masks and sitting in a wide circle, engaged in discussion, or labouring silently over their homework.

I have a friend who is a senior editor at my publishers'; —she is also an alum, Vassar '90. Occasionally, I send her pictures and sketches from all around campus, especially Sunset Lake, where, many years ago, she sat on a hill and read *War and Peace*. I cannot wait to tell her whenever I see her next that, exercising my creative option at this time, I have been holding office hours at the lake these days. My students and I walk around the water that reflects the trees and the blue of the sky. With wisdom borrowed from a great spiritual leader, I say to my students: Have calm thoughts. Meditate on the words you have written. And as you walk, imagine you are making flowers bloom under your feet.

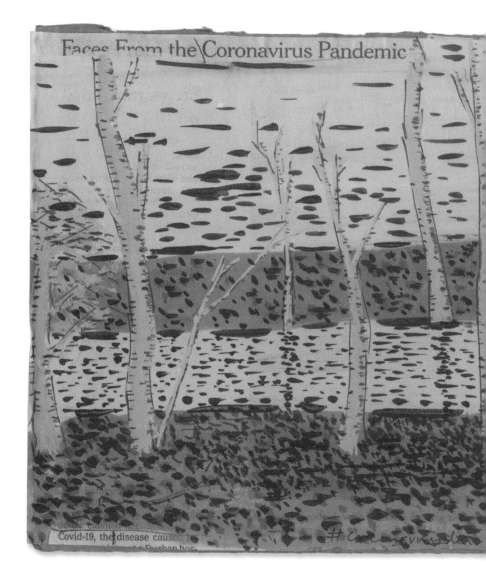

Covid-19, the disease caused t
Durban hos

Gouache and ink on newsprint, Poughkeepsie, New York, 2020

Fall, 2020. Next semester I will teach a writing course called 'Sick City'. It will focus on non-fiction reports on the Covid pandemic from cities across the world. The students will practise journal-writing, research and reportage. Readings will include Rivka Galchen's report from a hospital in New York City, Arun Venugopal's radio-report from a morgue, Arundhati Roy on the pandemic as a portal, Teju Cole's journal of the pandemic, Helen Macdonald on the comfort of common creatures, Zadie Smith on the virus as contempt, Danny Lyon's account of a visit to the ailing Senator John Lewis, Ali Bhutto on the curfew in Karachi, Wang Fang's *Wuhan Diary*, Slavenka Drakulic surviving Covid in Stockholm and Lorna Simpson's artwork in LA during the quarantine.

Gouache on paper, Poughkeepsie, New York, 2021

January 2021. A new year. Despite the 6 January assault on the Capitol, which to me was no less of a terrorist attack than the one on 9/11, a new government was sworn in on 20 January. For their school meeting on Zoom, my kids dressed up as Joe and Kamala: Rahul wore a blazer and Ray-Ban aviators, Ila tinted her hair and wore pearls. Among all the Americans I know or am friends with, there is a great feeling of relief and hope. But I lead a divided life. Half of my attention is forever on India. Thousands of farmers have been demonstrating

outside Delhi against the new laws that favour corporations. There were riots in Delhi on Republic Day and footage was aired in the news of spikes being driven into concrete on the highways to stop the farmers from reaching Delhi. But in this too, instead of despair, we must choose to find hope. Hope in the large number of citizens turning up to demand their rights despite the obstacles put in their way. There cannot be more vital signs of democracy than the multitudes on the streets, non-violently staking their claim to what is rightfully theirs.

On 23 February 2020, riots erupted in Delhi. The homes and shops owned by Muslims in northeast Delhi went up in flames after a ruling party politician, irked by the anti-CAA protesters in Shaheen Bagh, whipped up fanatical fury among his followers. The then US President, Donald Trump, landed in Delhi the next day. In upstate New York, where I live, I woke up to read online the NBC report with the headline: 'Deadly Violence Sweeps Indian Capital of New Delhi During Trump Visit'. Neither Trump nor his host Prime Minister Modi said anything to condemn or even acknowledge the violence. Later, the police filed cases against several individuals but Kapil Mishra, the politician who had apparently incited the riots, wasn't named anywhere.

The first anniversary of those terrible days is now approaching. There is a story that I wrote down in my notebook from one of the news reports I had read: 'A Muslim resident of Shiv Vihar kept pet pigeons. The mob burned down his home and then killed the pigeons by wringing their necks.' Were they Muslim pigeons? There is another brief, heartbreaking detail that I had recorded: 'A man returned to a street corner to sift with his hands through a pile of black and grey ash searching for his brother's bones. He had seen his brother on fire as he tried to flee the mob. He found charred bits that he was going to bury in a cemetery when peace returned.'

I believe we should remember what was done by our fellow human beings. We must fight for justice on behalf of those so grievously wronged. What is the central conceit of art? That someone reading or looking at your work will be moved, that your words or images will leave someone altered or changed. I cannot say I have bought into that worldview completely. But I do want to remember, and for my words or art to keep alive a memory.

Many lovers of Urdu poetry remember Bashir Badr's lines: '*Log toot jaate hain ek ghar banane mein / Tum taras nahin khaate bastiyan jalaane mein.*' (People go broke in building a home / And you remain unmoved as you burn down whole neighbourhoods.) The poet was speaking from experience. His own home in Meerut was gutted and reduced to rubble in the Hindu–Muslim riots in 1987. I made this painting with those lines of Bashir Badr in mind. I am saying that *I remember, I remember.*

'Delhi February', gouache on board, February 2021

My son, Rahul, is in middle school and is attending his classes online during the pandemic. His English teacher has the whole class writing odes to ordinary things. But we are far away from Neruda's age; my kid's ode to glazed doughnuts, for example, doubles as a Yelp review. In an effort to offer an ode to something ordinary, I suggested we paint a pair of shoes. The painting that you see on the opposite page is a result of that collaboration. Except, for Rahul, there's nothing ordinary about his boots. They are his most extraordinary possession: a pair of Timberland's.

The pandemic has been hard on our children who have been deprived of playing outdoors and birthdays and ordinary school. So, it is pleasing to me that Rahul's teacher has asked them to look at and find delight in ordinary things. It is such an important part of childhood, the feeling of wonder.

This morning, seated at my desk, I'm asking myself how I would like to greet the future? In the days that are left to me, who is it that I want to be.

The person I like most is the one I am when reading a story by Anton Chekhov or Ismat Chughtai or Alice Munro or Vinod Kumar Shukla. When reading them, I enter another, rarer state of mind—in which I'm paying attention to the inner workings of the world. I am calm, and yet all my senses are on alert: I feel I'm at rest as I receive news from a particular corner of the human heart. The other world, of so-called real news,

Ra Kumar
2/1/21

Gouache on paper, Poughkeepsie, New York, February 2021

with its noise, doesn't interest me at this time. The
conflicts on the page, the choices that the characters
are making, these appear more meaningful and true.
The nuances of any exchange, of every change, prickle
my skin. When I'm reading like that, with a sense of
focus and maybe even empathy, I feel whole and it is
as if my humanity has been restored. So, there is the
answer to the question I raised earlier about how I
would like to meet the future.

The question I'm really asking, I realize now, is how to be human. When I write, or read, or paint, I am more of a human than I am a gadget. The words you are reading I first put down in longhand using a sharpened pencil. While I was writing, I did not check my email. At such moments, I feel I'm myself rather than a body attached to a buzzing phone.

Dear days that are passing: will you please whisper in the ears of the days that are to come, that that is my greatest wish?—To be someone who pays attention. Bring me quietness, bring me caring. Make of me a reader, a writer, an artist.

Gouache on paper, Yaddo, Saratoga Springs, New York, 2019

Keep a Journal, Make a Mark

Nine years ago, I read an oft-quoted line by the writer Annie Dillard: 'How we spend our days is, of course, how we spend our lives.' My days were filled with wanting to write but not actually writing. I had a new baby and classes to teach. So I decided that I would make a small check mark at the back of my notebook if I had done my quota of writing for the day. It was almost like keeping a diary. It changed my life.

I was writing about my hometown of Patna, where rats had stolen my mother's dentures and, the police claimed, drunk all the confiscated liquor. I don't think

I skipped even a day, and when the year ended, I had completed a short book. Every day I had turned to the back of my notebook, put down the date, and then made a mark.

The method was a success; I had now written a book by writing every day. I wasn't going to give it up. In the minutes between classes, or on trains or in the waiting room at the paediatrician's, I would write my daily words in a small brown notebook that fit in my pocket, and then count them to make sure I'd hit the target. Once I had done the work and drawn that small mark, it seemed possible to imagine I would spend my life writing.

In the back of my notebooks over the years, I see the rows of check marks that stand for an unknown number of hours of toil, but also words (rejected by ___, rejected by ___, rejected by ___, accepted by ___), figures (20K, 30K, 50K, 90K—total word counts) and dates (the signing of a contract on a novel on 7 March 2017; the death of my publisher on 30 December 2019; the acceptance by HarperCollins India of the book that you are holding in your hands on 22 January 2021).

This is a plain, rather primitive form of record-keeping; its spine is the long column of marks on a page. I prefer this practice over the apps on our smartphones that serve as journals in the age of surveillance capitalism. These apps count each step we

take, store our memories in the form of photographs, even record the places where we have parked our cars. They hoard such a surfeit of information as to render meaningless any painstaking individual action. The check mark is Gandhi in a world built by Bezos and Zuckerberg. It is the same with drawings and paintings, not least because they are not made by instant clicks on a smartphone; they take time and attention.

The Japanese–American conceptual artist On Kawara is famous for having produced nearly three thousand canvases that record only the date on which they were painted. If he was unable to finish the day's painting before midnight, he destroyed it. I'm drawn to the rigour of Kawara's routine and to the fact that he looked at each day with an equal eye: there is nothing in his paintings to distinguish them from each other except their unique dates.

I am a writer; so every day I write. The days I am given are only for writing. Maybe you are a writer, too; maybe you are not. The point still stands. The mark you make in your journal is more important than whatever comes of the daily task whose completion you're recording. The first represents actual living; the second merely a life.

Acknowledgements

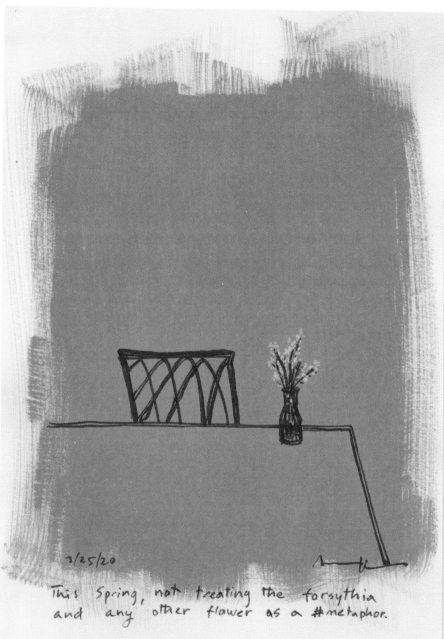

3/25/20

This Spring, not treating the forsythia
and any other flower as a #metaphor.

My main thanks go to Hemali Sodhi of A Suitable Agency who asked for this book, an offering of flowers, while the pandemic raged around us; Udayan Mitra at HarperCollins India for his immediate enthusiasm and editorial advice; Shatarupa Ghoshal for her close attention to the text; and Gavin Morris for his beautiful design. Thank you to Michael Ondaatje for advice, Ian Jack for always responding to my questions and Teju Cole for his accompanying playlist 'Blue Books'. My thanks also to Henry Chapman, Amit Chaudhuri, Kiran Desai, Geoff Dyer, Gulzar, Emilie Houssart, Martha Jessup, Liz Johnston, Jenny Offill, Dushko Petrovich, Elaina Richardson, Omid Shekari, Shane Slattery-Quintanilla and Xinran Yuan. Some of the entries in this diary are drawn from my recent publications in *The New York Times*, *Granta*, *Indian Quarterly*, *BRICK*, *BBC Hindi*, *Mint Lounge*, *Virginia Quarterly Review*, *Hyperallergic* and *The Indian Express*.

About the Author

Amitava Kumar is the author of several books of non-fiction and three novels. His work has appeared in *Granta*, *The New York Times*, *Harper's*, and several other publications. He has been awarded a Guggenheim fellowship and residencies from Yaddo, MacDowell and the Lannan Foundation. His novel *Immigrant, Montana* was on the Best of the Year lists at *The New Yorker*, *The New York Times*, and on Barack Obama's list of favourite books of 2018. His new novel *A Time Outside This Time* has been described by Pulitzer-winner Ayad Akhtar as 'an absorbing portrait of an inspired artist in the midst of our maddening cultural moment'. Kumar is professor of English at Vassar College in upstate New York.